IMAGES
of Rail

BIG BEND
RAILROADS

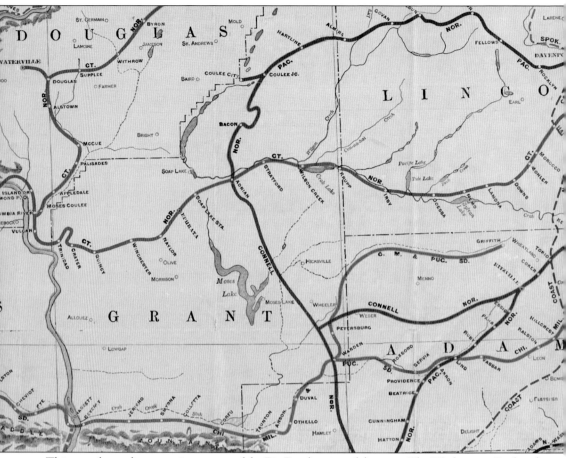

This map shows the approximate area of the Big Bend region of the state. The Washington Railroad Commission was a three-man board charged with keeping the railroads in check in the early days of Washington State. As part of their process, they had maps drawn up every year to show the railroad lines in the state. This crop of the larger full-state map shows the approximate borders of the Big Bend area. There is one mistake on the map; though all the grading was done, the line from Ritzville that reads, "Connell Nor.," was never completed. (Courtesy of the Washington Utilities and Transportation Commission.)

ON THE COVER: This scene is along a seldom-seen section of railroad through Dry Coulee. Originally built as the "Adrian Cut-off" in 1903, it allowed shipments on the Central Washington Branch to Coulee City to head west quickly instead of the reverse direction to Spokane and then west. After this line was built, it also allowed people traveling to the county seat in Waterville the ability to take a Great Northern (GN) train to Adrian, stay the night at a hotel there, catch the Northern Pacific (NP) train for Coulee City, and then take a stagecoach for the final stretch. This line was also crucial to the building of Grand Coulee Dam, as many thousands of boxcars of cement were handed off from the GN at Adrian to the NP to Coulee City. The cutoff was considered important enough to the NP that it built a small engine facility near the GN depot at Adrian. There was a two-stall roundhouse, turntable, and coaling dock. (Photograph by George Neff, courtesy of John Neff.)

IMAGES
of Rail

BIG BEND
RAILROADS

Dan Bolyard

ARCADIA
PUBLISHING

Published by Arcadia Publishing
Charleston, South Carolina

Printed in the United States of America

Library of Congress Control Number: 2014940335

For all general information, please contact Arcadia Publishing:
Telephone 843-853-2070
Fax 843-853-0044
E-mail sales@arcadiapublishing.com
For customer service and orders:
Toll-Free 1-888-313-2665

Visit us on the Internet at www.arcadiapublishing.com

To those who have an interest in preserving history in the Big Bend region

CONTENTS

Acknowledgments 6

Introduction 7

1. The Northern Pacific Railroad 9

2. The Great Northern Railway 37

3. The Milwaukee Road 71

4. The US Construction Railroad 101

5. The Mon-Road Railroad 119

6. The Waterville Railroad 125

ACKNOWLEDGMENTS

This has been a large undertaking for me, and it would have not been completed without the helpful input of other railroad historians. Dave Sprau, a retired train dispatcher and historian, reviewed caption material and made important observations, as did Allen Miller, a retired railroader and Milwaukee Road history expert, who also provided photographs. Bob Kelly, the collection manager of both the Skykomish Historical Society and the Great Northern Railway Historical Society, gave important suggestions and helped track down photographs. Sean Hess, the Pacific Northwest regional archaeologist of the US Bureau of Reclamation, looked over the Grand Coulee section. I am also indebted to Darrin Nelson, a fan and blogger of the Great Northern Mansfield Branch, for his help in tracking down photographs. Charles Mutschler, the archivist at Eastern Washington University, helped with many photographs. Steve Rimple, the grandson of Monte Holm, is passionate about the history of his grandfather and was very generous as well.

Others who were instrumental with this book are John Phillips III, for his interest in the Northern Pacific; Paul Krueger, secretary of Cascade Rail Foundation; Pat Gies, Odessa Historisches Museum; LuAnne Morgan, Othello Community Museum; Crystal Lindgren, Grant County Historical Museum; Harold Badten, Waterville historian; the nice folks at the Davenport Historical Society; Bruce Butler; Bill Sornsin; Dale Swant; Mac McCulloch; Freya Hart; Ann Golden; Kathleen Keifer; Lynne Brougher; the late Alan Eisenberg; and Karen Rimple. Special thanks go to Suzanne Wilson for her ability in making sure all the grammar and punctuation is in the proper place.

I also wish to thank my editor at Arcadia Publishing, Rebecca Coffey, for her expert guidance and prodding.

Special thanks go to my wife, Dani, and daughter, Danika, who let me have plenty of extra time researching and typing for the last six months.

Unless otherwise noted, all images are from the author's collection.

INTRODUCTION

The first lines constructed in the Big Bend were part of the Seattle, Lake Shore & Eastern (SLS&E), which wanted to build across the state line. It started constructing its Eastern Division in 1888. This alarmed the established Northern Pacific, which then created a subsidiary, the Central Washington Railroad, to build into the Big Bend as well. Ultimately, the NP bought the SLS&E, ceasing further competition.

The Great Northern was the first main line to cross the Big Bend area; it followed the Crab Creek drainage for a long portion. Most construction through the area was completed in 1892, with the line finished as a through route in early 1893.

In 1903, a connection from the NP at Coulee City to Adrian on the GN was built, allowing grain shipments to be more directly shipped to the West Coast without having the backhaul to Spokane and then west.

The Chicago, Milwaukee & St. Paul started to set up its Pacific Extension in 1905, with the company doing construction through the Big Bend, most commonly known as the Chicago, Milwaukee & Puget Sound Railway. The line was completed as a through route in 1909.

Another NP subsidiary was established in 1909, the Connell Northern, which completed a line from Connell to Adrian. This allowed the NP to have a large loop through the Big Bend. Plans were to use this line to construct a cutoff across the Big Bend, bypassing the dip down to Pasco.

Part of this section was built from Ritzville to Bassett Junction, north of Warden, with surveys all the way through to the Ellensburg area. The grade of the uncompleted section to Ritzville can be seen today.

The town of Waterville had longed for railroad access, but when the GN bypassed the town while constructing to Mansfield in 1909, the citizens there formed their own line, the Waterville Railroad, to build the five miles from Douglas to Waterville.

Branch lines to Moses Lake and Marcellus were constructed in the 1910 time frame, allowing the Milwaukee to gain much needed local traffic. These were the only branches the Milwaukee had through eastern Washington, save for the line to Spokane.

Further major construction in the area resumed when the building of Grand Coulee Dam was imminent. The NP proposed building a line from Coulee City north through the Grand Coulee, if it were allowed exclusive access to transporting construction materials. The government balked at the NP's demand for exclusive access and put the line up for bidding. The NP did get the bulk of the shipments.

The first line to disappear in the Big Bend was the Waterville Railroad, which lost over 50 percent of its tracks in the floods of May 1948. The flood also took out a large section of the GN line to Mansfield. The Waterville was never rebuilt, while the GN did fix its line to Mansfield.

The next line to be lost was the one to Grand Coulee Dam in 1950, as most of it was to be flooded by what is now Banks Lake. Portions of the line, along with the old engine shop at Odair and the crane building, can still be seen today.

Five miles of new track were constructed in 1969 when the Milwaukee Road announced it was building to the new industrial park at Royal City.

Abandonments began in 1979, when the line from Coulee City to Adrian was taken up. The removal contract was given to Monte Holm of Moses Lake, who wanted the rail for his train. Trains had been discontinued on this section since the mid-1950s.

The Milwaukee Road quit serving the lines west of Miles City, Montana, in March 1980, and service to the major industries in the Moses Lake and Othello areas was transferred to the Burlington Northern. Only the main line from Warden to Royal City Junction survived, as did the spur to Royal City and part of the branch to Moses Lake.

The next section to be taken up was the one from Adrian to Wheeler in 1983. This section had most recently been used to transport sugar beets from the greater Quincy area to Wheeler via Adrian.

Also taken up in 1983 was the last remaining section of the Lake Shore out of Davenport. This had been a short spur that remained to serve local grain elevators south of town.

In 1985, the branch to Mansfield was removed although it was nearly saved. A vote by residents to create a rail authority to operate the line was narrowly defeated. The Washington Central Railroad was created in 1986 to take over the operation of the line of the Burlington Northern from Connell to Wheeler and the former Milwaukee Road from Warden to Othello and Royal City and Moses Lake, amongst other lines in the state.

The branch to Coulee City survived until 1996, when it became part of the short-line Palouse River & Coulee City. Ten years later, the line was sold to the State of Washington, with a new operator taking it over, the Eastern Washington Gateway.

The Washington Central ceased operations in 1996, when it was bought out by Burlington Northern & Santa Fe (BNSF) to gain control of other lines it owned in Washington state. The lines in the Big Bend were turned back over to the Columbia Basin Railway, which had similar ownership to the Washington Central.

This book is loosely based on the research I have compiled over the years on my Big Bend Railroad History blog at http://sdp45.blogspot.com/.

One

THE NORTHERN PACIFIC RAILROAD

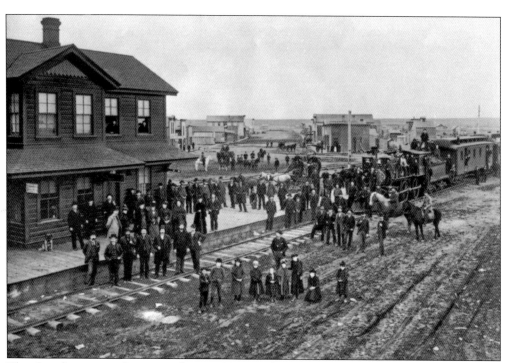

The idea of getting one's picture taken in 1890 must have been quite a novelty, as nearly the whole town of Coulee City has shown up for this photograph. The Central Washington Railroad, a subsidiary of the Northern Pacific, was completed to town in 1890 after a pause of about a year at Almira. Seen on the left is an atypical depot, as all the others along the line were of the same design. The upper story provided living quarters for the agent of the railroad.

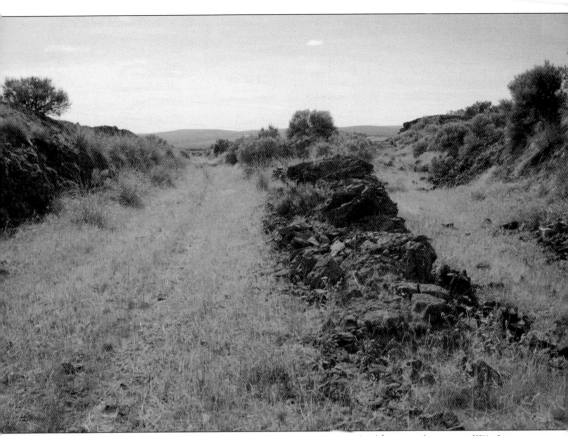

The Seattle, Lake Shore & Eastern Railway had grand plans to build across the state of Washington. Part of the railway's line went through the Big Bend country from Spokane to Waterville, Wenatchee, and Cady Pass, and then it connected with its lines on the west side of the state. The company started grading east from Spokane and actually completed a line nearly to Davenport. A crew was sent ahead to start on a hard section of line from Coulee City up the coulee wall. The Northern Pacific did not intend to let the Lake Shore have a section of line into the Big Bend without a challenge and sent its own crew out to secure certain areas where there might be room for only one line. Both crews did indeed clash at a gash in the basalt, where both lines curved into a narrow spot, but they then went on their ways west. The NP crew was better staffed and had better equipment, but the Lake Shore crew certainly did a great amount of work. This unfinished cut, just beyond that contested gash and hanging toward the right, shows they were blasting into about 40 feet of basalt.

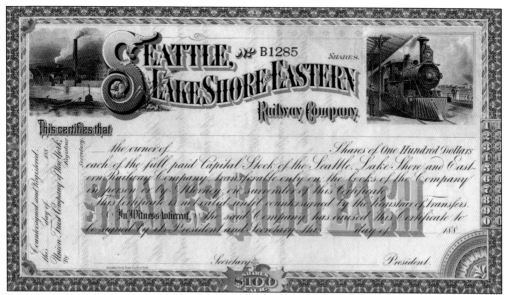

During the heyday of railroad construction in the Big Bend area, the way to raise money for construction was to issue stock and sell it to whomever could pay. Often, the stock was issued to the company doing the actual construction of the railroad. The Seattle, Lake Shore & Eastern issued a lot of stock over its short lifetime. All of its assets were eventually acquired by the Northern Pacific.

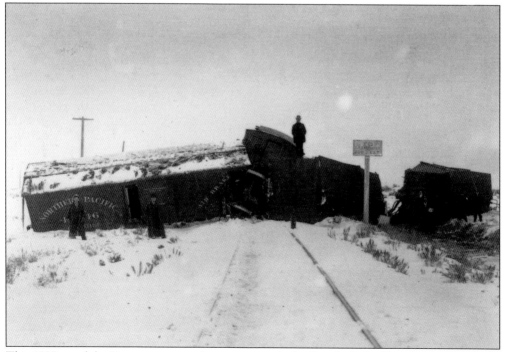

This 1897 wreck by Davenport, near the crossing with the Seattle, Lake Shore & Eastern, looks like the collision of two trains. This was the daily passenger train, complete with railway post office. (Courtesy of the Lincoln County Historical Society.)

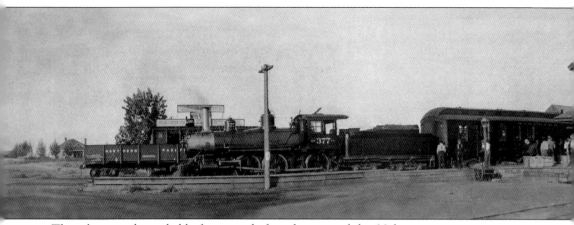

This photograph, probably from just before the turn of the 20th century, gives an amazing glimpse into what life was like back then. People came and went from town via the depot. They also bought coal for heating from the coal dealer right behind the smokestack of the steamer.

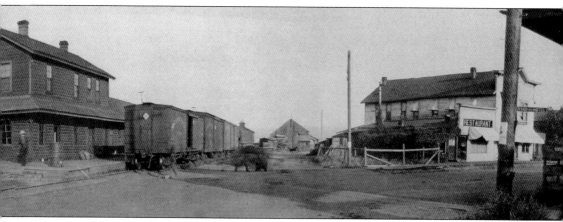

Visitors could stay in the hotel, and locals could have meals there. Everything was shipped to town via boxcar. Grain was transported in 50-pound sacks inside those same boxcars. Life revolved around the depot.

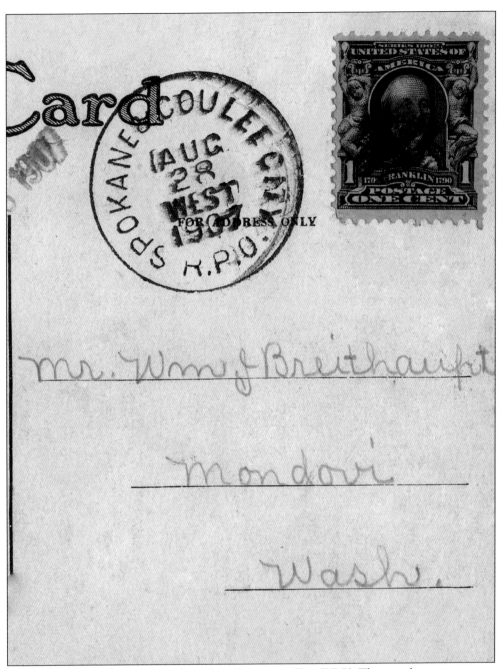

Card

SPOKANE & COULEE CITY R.P.O.
AUG 28 1907
WEST

FOR ADDRESS ONLY

ONE CENT

Mr. Wm. J. Breithaupt

Mondovi

Wash.

One of the ways mail was delivered was by railway post office (RPO). This was done via contract between the post office and the railroad. Almost every rail line had RPO service. The designated train had a special car that had mail from the regional center in bags for towns along the line. As the train passed through each town, a bag was thrown off to the station and another taken aboard. That bag was then sorted and placed in the bags for further delivery down the line or for return to a regional center. Since the RPO operated in each direction, towns received twice-daily mail service. The postmark seen here was from the Spokane & Coulee City RPO from August 28, 1907, via the westbound train. Service along this line was dropped in favor of trucks in 1954.

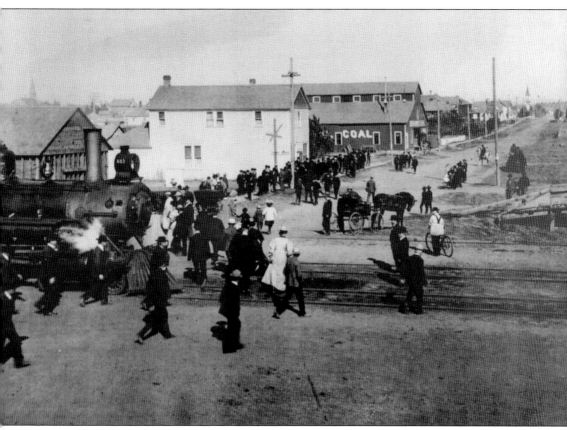

This pre-1910 view in Davenport shows what must have been the arrival of an important train in town. There were not many events that could draw such a large crowd. (Courtesy of the Lincoln County Historical Society.)

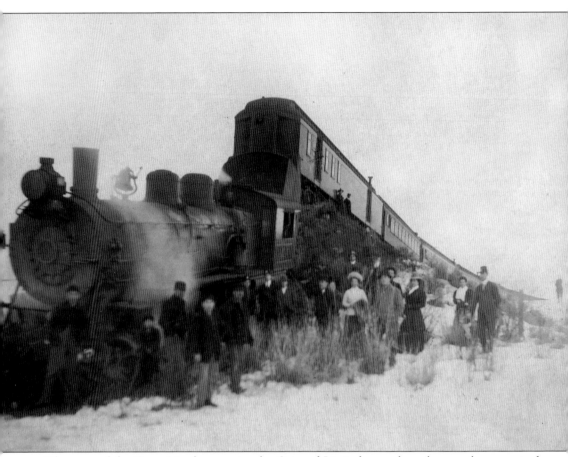

The crew of the Great Northern train, the *Oriental Limited*, must have been rather surprised when it ran out of track just beyond Coulee City in early 1909. The train would have had the regular GN crew, plus a Northern Pacific pilot engineer who knew the line. Flooding of Crab Creek near Wilson Creek washed out the GN tracks, causing the GN to reroute trains over the NP. The train would then continue over the Adrian cutoff, south of Coulee City, to Adrian, where the GN main line would be regained. However, the switch at Coulee Junction was set for a movement to Coulee City, and by the time the train stopped, the locomotive went over the end of the track west of town. This track was to have continued to the mines of the Okanogan, but rail and trestles were never placed beyond Coulee City.

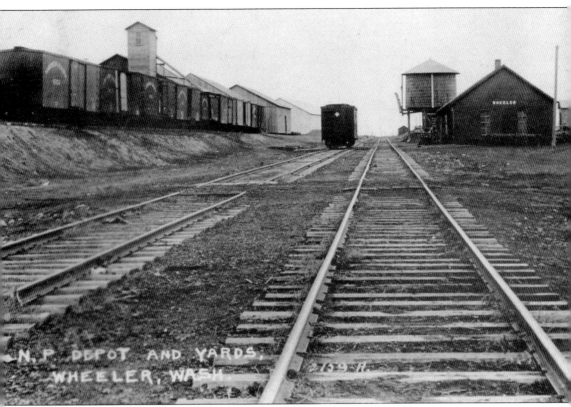

N. P. DEPOT AND YARDS,
WHEELER, WASH. 2769-A

Wheeler is the current end of track for this one-time looping branch line that connected the Northern Pacific main-line points of Connell and Cheney. This photograph dates from about 1910 and shows the original depot and water tank. The tracks are still laid out like this, and the grain warehouses on the left have given way to large tanks and an elevator. The foundation for the depot and water tank can still be seen today. The building on the far right is still standing.

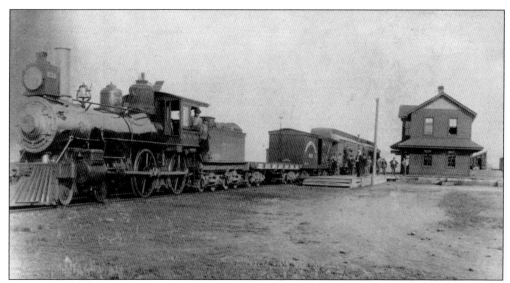

This photograph dates from at least 1897, when this particular locomotive was renumbered 733. Of note is the shine on the engine, which was due to the crew taking pride in it. The boxcar was probably used for express freight and other small deliveries. The first car behind it is a railway post office. (Courtesy of the Grant PUD Archives.)

When the railroad was built to Coulee City, it was self-reliant in all aspects of operation. To have a shovel such as the one pictured, plus skilled operators, was not uncommon. This machine was likely used to create ditches and such along the right-of-way to help drain water properly. (Photograph by C.W. Neihart.)

A high-ranking official was out inspecting the Northern Pacific Branch this day. Note how the car is fitted to run as a train, with a car number on the door, cowcatcher of heavy metal on the front, and the white flags in front of each door. (Photograph by C.W. Neihart.)

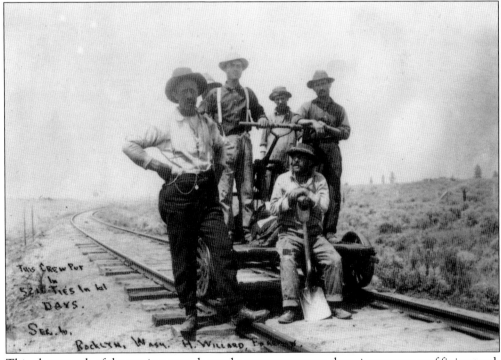

This photograph of the section crew shows that manpower was the primary means of fixing track in the 1910s and 1920s. The average of 85 ties a day is impressive considering the men used picks and shovels to dig the ties out. (Courtesy of the Lincoln County Historical Society.)

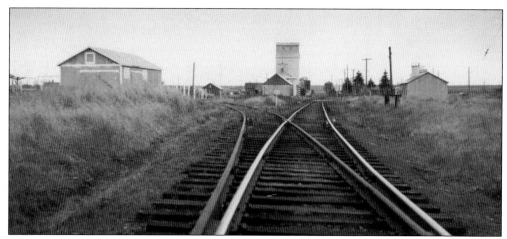

Milepost No. 42 is on the east side of Davenport. The tracks of the main line are rather shiny, leading to the conclusion that the tracks diverging to the left are not often used. In the distance, one can see the water tank with the motorcar shed in front of it. The tallest building in this image is still standing today, although larger grain tanks now dwarf it. (Courtesy of Michael Denuty.)

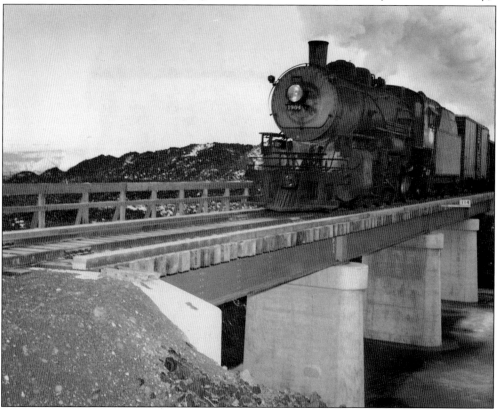

The newest section of track on the Adrian cutoff was this bridge, completed in late 1947. Pictured is the first train over the bridge on January 19, 1948. It was built due to the main canal from Coulee City to Long Lake passing here. The bridge was scrapped when this section of line was abandoned in 1979. (Photograph by the US Bureau of Reclamation, courtesy of the Grant County Historical Museum.)

Boxcars were badly needed in the summer of 1948 to handle the record-breaking wheat crop in eastern Washington. Major flooding during May of that year caused all sorts of damage throughout the Northwest. The Great Northern Branch to Mansfield was washed out in almost every place there was a bridge, stranding 61 boxcars on the plateau. As a desperate measure, a way to ship the boxcars via highway from Mansfield was devised. Pictured is the first of 61 cars to be moved this way and deposited on the Northern Pacific tracks in Coulee City. (Photograph by Paul Neihart.)

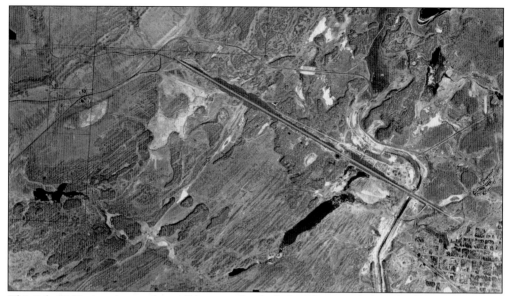

This July 1949 view shows what will become Banks Lake. The scars below the dam in the basalt are from the railroad grades built across the coulee floor from Coulee City to the west. The most complete one, built by the Central Washington Railroad, was finished to the top of the coulee to the west. The other was by the Seattle, Lake Shore & Eastern. (Courtesy of Douglas County.)

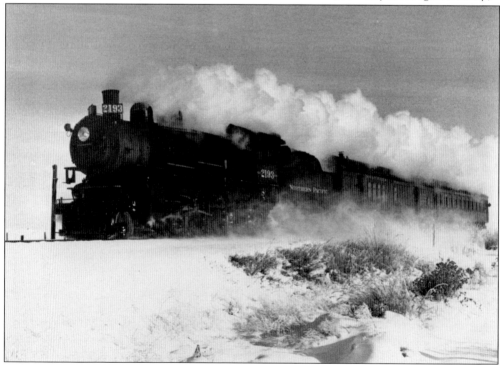

Train No. 305, the daily westbound passenger train between Spokane and Coulee City, is at the first crossing west of Hartline in 1949. Steam Engine No. 2193 was part of the standard class of locomotives used on the line at that time. The first car behind the tender is a railway post office.

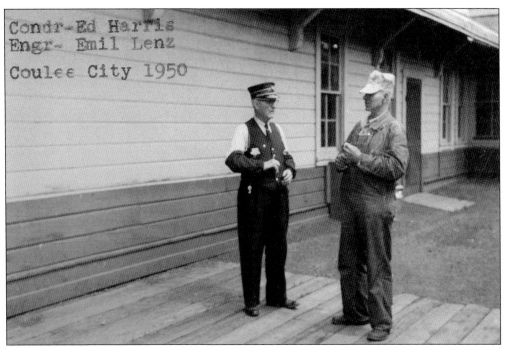

Condr-Ed Harris
Engr- Emil Lenz
Coulee City 1950

Immediately prior to departure, the conductor and engineer would normally compare watches. The conductor would then give the engineer a set of train orders, and they discussed anything required by them. Often what followed was general friendly chitchat.

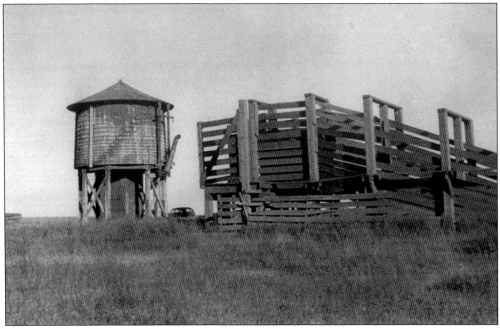

This view shows the original water tank at Bruce, Washington, about four miles east of Othello. There was still the shipment of livestock at the time, and this image shows the loading chute to the stockyard. Nothing in this May 14, 1956, view still stands. The water tank was replaced by a second water tank, which itself was torn down in 2012. (Courtesy of the Othello Community Museum.)

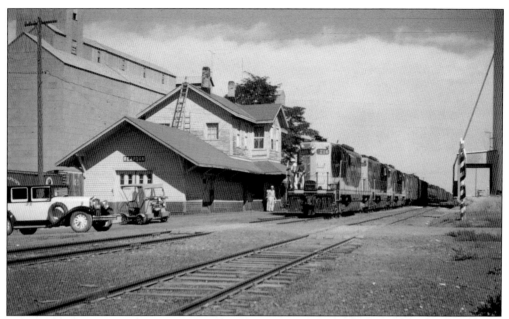

In 1961, the agent at Reardan was on vacation when photographer Bruce Butler was filling in for him. At the time, the *CW Local* (Central Washington) ran from Spokane to Coulee City on an "out one day, back the next" basis. The depot is long gone, but one can still see a small section of the depot platform just east of this crossing. (Photograph by Bruce Butler.)

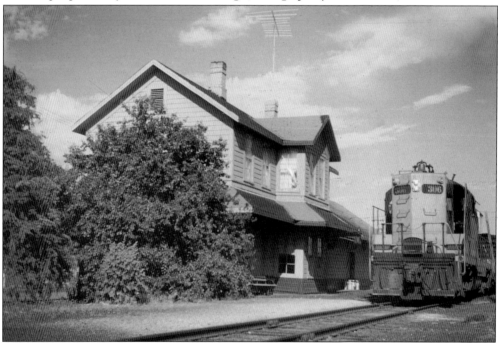

The *CW Local* has only one locomotive on this early spring day in 1961. The agent lived in the second story of the depot until it was closed or the functions of the agent transferred to another depot. Modern times have caught up with the Wilbur depot in this image, as it sports a television antenna. (Photograph by Bruce Butler.)

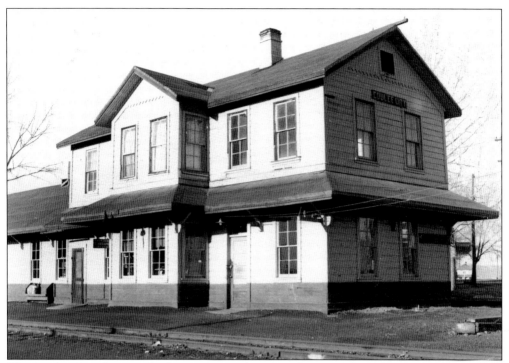

The Coulee City depot is the last surviving depot on the Central Washington Branch. It lost the upper floor in a 1966 remodeling prior to construction materials being shipped for the third powerhouse of the Grand Coulee Dam. The depot was moved to a nearby lot in 1977 and serves as the town's senior center.

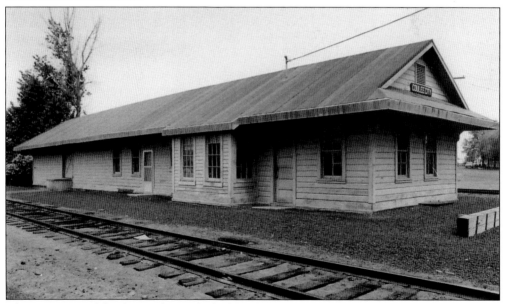

This 1973 view of the depot is how it looked for the last 10 years it sat next to the tracks. Its 1966 renovation helped to strengthen the foundation and give it more structural integrity when it was moved in 1977. As the town's senior center, it has gained an addition, but it retains the distinctive Coulee City name boards on both ends. (Photograph by Norm Hochhalter.)

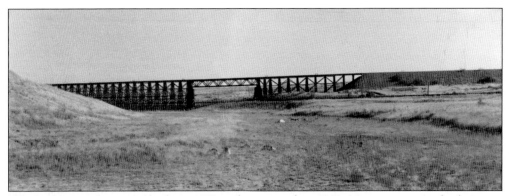

The bridge at Adrian was built in 1910 and renovated in 1943. Movement over the line as a through route from Connell to Coulee City and Cheney ceased after the early 1950s. (Photograph by Dorothy Kimball, courtesy of Mike and Penny Kimball.)

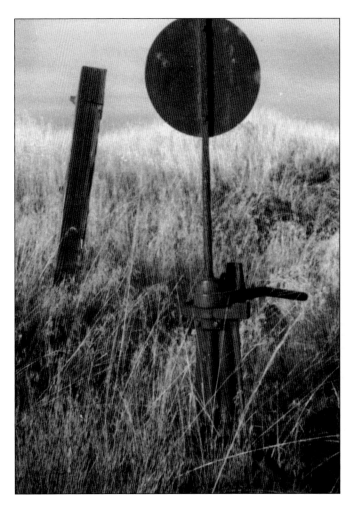

The last train left over 20 years ago, yet this switch stand remains at the oddly named siding of Bacon. This location was the only siding on the Adrian cutoff. By the end of 1978, the switch stand had been relieved of its duties, along with the rest of the cutoff, and sold for scrap. (Photograph by Dorothy Kimball, courtesy of Mike and Penny Kimball.)

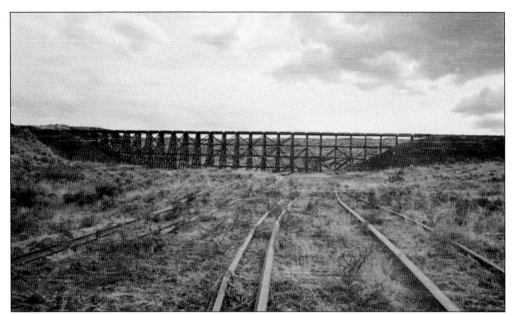

Monte Holm bought the rights to scrap the railroad tracks from Adrian to Coulee City in 1978. Of note about the line were the major wooden trestles through Dry Coulee, which had been upgraded in 1931 and 1935 in anticipation of the building of Grand Coulee Dam. (Photograph from the *News & Standard* archives, courtesy of ShirleyRae Maes.)

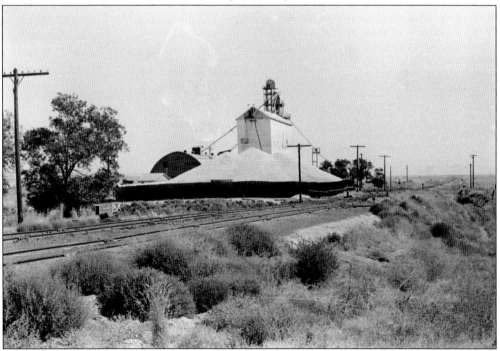

An abundance of wheat in 1978 was the reason for this photograph taken at the east end of Hartline. Not every year is there a bumper crop that fills the elevator and then some. This elevator was upgraded around 1986 to quickly load covered hopper cars with grain. (Photograph from the *News & Standard* archives, courtesy of ShirleyRae Maes.)

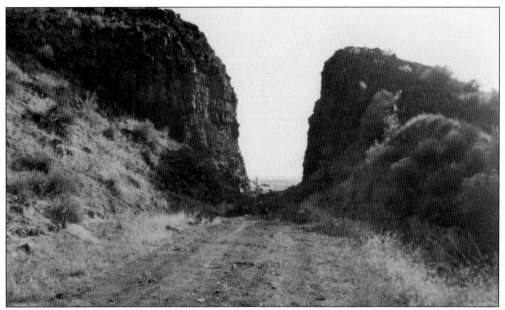

This rock cut is just north of Adco. It became the site of the Winston-Utah Company spur, the same company that won the bid to build the Dry Coulee Siphon in the 1950s just to the right and on the other side of the cut. (Photograph by Dorothy Kimball, courtesy of Mike and Penny Kimball.)

During the sugar beet campaigns, this switch at Adco was important. The beets shipped from Quincy would come north from the GN to this switch and then take the right to go on toward the sugar plant at Wheeler. (Photograph by Dorothy Kimball, courtesy of Mike and Penny Kimball.)

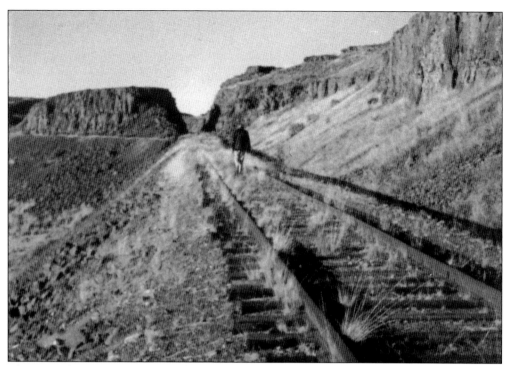

This spot, about five miles south of Coulee City with lots of scabland, sagebrush, grass, and rusty rails, accurately portrays the typical scenery of the Adrian cutoff after service ended on this stretch in the 1950s. (Photograph by Dorothy Kimball, courtesy of Mike and Penny Kimball.)

This view, near the intersection of Road 12 Northeast and Stratford Road, barely shows that there was a rail line here. The tracks were removed in 1983 and Stratford Road subsequently repaved. All traces of the nearby siding of Gloyd are gone. (Photograph by Dorothy Kimball, courtesy of Mike and Penny Kimball.)

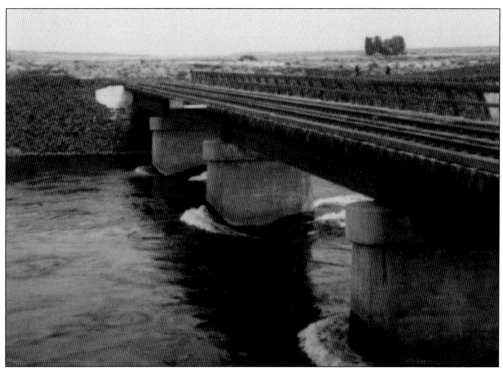

Finding trains after the 1950s on the Adrian cutoff was impossible. After abandonment was announced in 1979, a photographer snapped this image of the 1947-built bridge over the main canal near Summer Falls. The metal parts were salvaged at that time, but the concrete pillars in the canal remain today. (Photograph by Wayne Bolyard.)

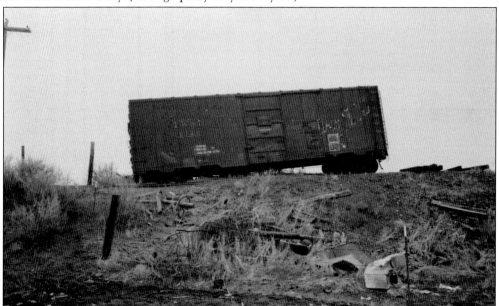

This unfortunate car, near the end of the era of loading boxcars with grain in 1979, has come loose and fallen off the end of the track at Coulee City. (Photograph from the *News & Standard* archives, courtesy of ShirleyRae Maes.)

One of the last stands for the early streamlined diesels from the late 1940s and early 1950s that helped vanquish steam engines was on the *CW Local*. Most of these locomotives were expected to only last about 15 years. However, Burlington Northern was very short of power in the early 1970s, so many of them were overhauled and sent out to continue to work. (Photograph by Brian Ambrose.)

While the *CW Local* is known for wheat, Creston for a time was known for its wood-chip loader. A *Creston Turnaround Local* worked at Creston to perform switching at the chip spur and to help with local switching during peak grain loading times. Note the loads of wood chips behind the locomotives in this view near Creston. (Photograph by Brian Ambrose.)

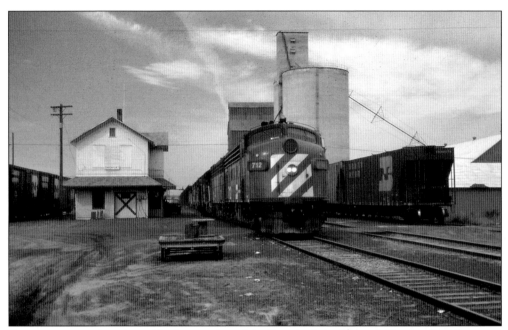

Davenport was a junction with the remains of the Seattle, Lake Shore & Eastern line that once ran to Spokane. After 1900, the line only went from Davenport to Eleanor. It was abandoned in 1983. The boxcars to the left of the depot in this September 1980 view are for loading on the soon-to-be removed line. (Photograph by Brian Ambrose.)

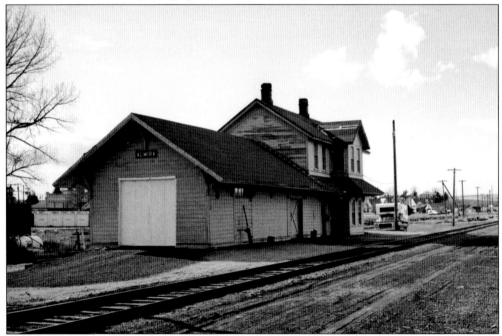

By 1968, there was no full-time agent at Almira; the agent from Davenport worked part-time there. In this April 1981 photograph, the depot is still clearly being used. Not long after the image was taken, the BN thought enough of the building to paint it typical BN depot colors used elsewhere. By 1984, it had been torn down. (Photograph by S.L. Dixon.)

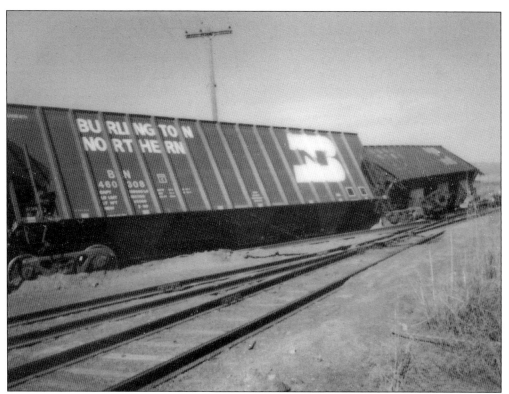

Loaded grain cars have a higher center of gravity when compared with empty grain cars. What likely happened here is one of the wheels picked the switch and tried to go against the direction for which the switch was lined. (Photograph by Wayne Bolyard.)

Sagebrush growing in the tracks is a sure sign that this photograph was taken at the Adrian cutoff. The c. 1980 view, near the crossing at Road 20 Northeast near Adrian, shows the brush growing near the tracks and the rusty rail waiting for the next train that would never arrive.

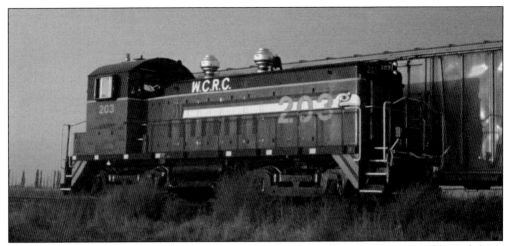

The Washington Central started operations in 1986 with a collection of unwanted branch lines sold off by the Burlington Northern. The BN had reorganized the branch to the Moses Lake area to include a section of Milwaukee Road to Moses Lake proper, splicing it into its former Northern Pacific Branch at Wheeler. Washington Central operations were initially conducted with little switchers, like No. 203 seen here.

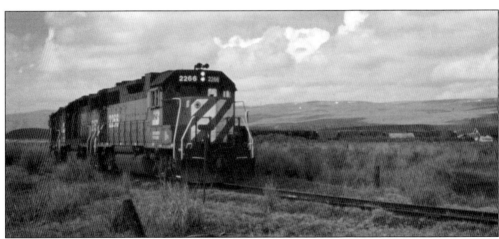

The Central Washington Branch during the early 1990s was run pretty much like it always had. The grain elevators would order cars to fill, and the railroad would haul them to market. On this day in 1993, the engineer wanted a quiet trip back to Spokane, so the front locomotive was left to idle all the way home.

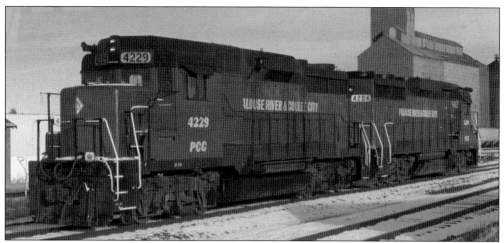

The Palouse River & Coulee City (PCC) was the name of the short line that bought the CW Branch from BNSF. Operations did not change that much, with trains of grain hopper cars going from the elevators to market. The Washington State Department of Transportation bought the branch in 2006, but the PCC name survives on other lines in the state.

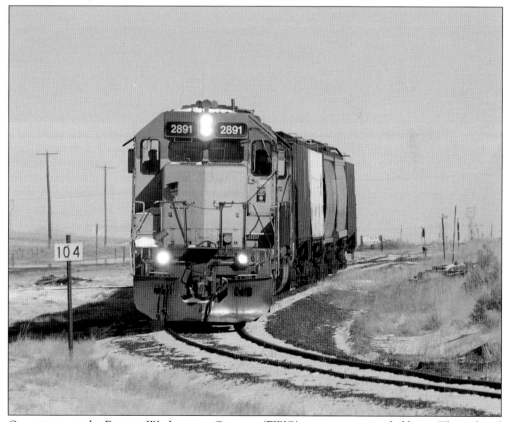

Operations on the Eastern Washington Gateway (EWG) are on an as-needed basis. The railroad responds to cars being delivered and picked up rather than on a regular schedule. As such, train sizes fluctuate. While the tracks are owned by Washington State, operations are contracted out to the EWG.

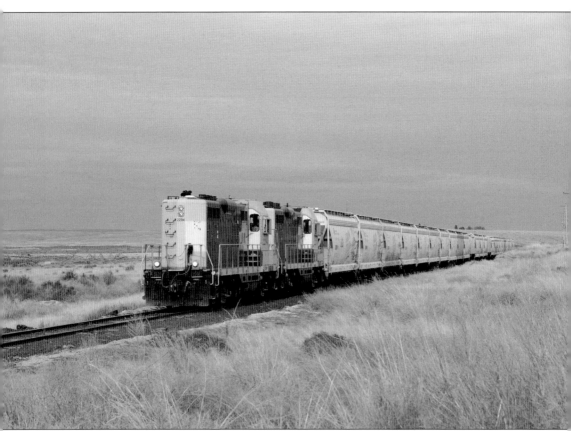

Operations on the branch line to Schrag are performed on an as-needed basis and are hard to predict. When the line does run, the Washington State Department of Transportation–owned grain hoppers are seen in service. These were purchased by the state for the short-line railroads in the area, such as the Columbia Basin Railway seen here. This section of track was built by the Northern Pacific as its "Ritzville Branch," which allowed faster running across Washington state, bypassing the loop down to the Pasco area and back up. This line was graded all the way from Ritzville to a place south of Warden called Bassett Junction. Tracks were only laid from the junction to Schrag about the time of World War I. Nearly the whole grade for this section can be seen along Interstate 90 today.

Two

THE GREAT NORTHERN RAILWAY

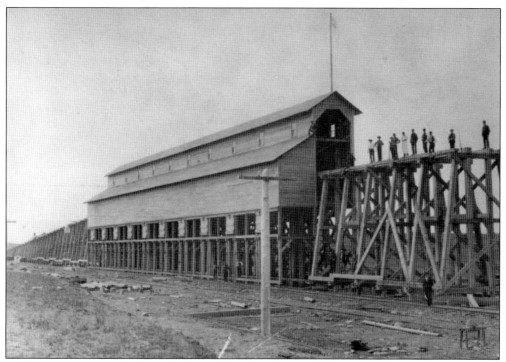

Coaling docks on a main line were usually of significant size. A carload of coal was left at the base of the ramp and then pulled up with a winch into the structure where the car was dumped. This brand-new tower is seen under construction at Harrington in 1893. (Courtesy of the Lincoln County Historical Society.)

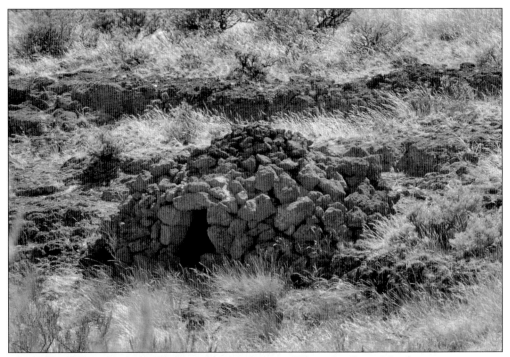

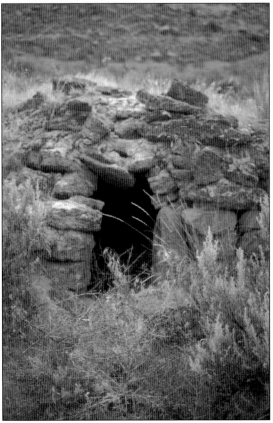

When the Great Northern was constructing its line between Quincy and Trinidad, camps were set up for the largely Italian crews working there, as blasting through all the rock would take a significant amount of time. Many stone ovens were used in camp, which were created by surrounding a large fire with rocks that would become heated. The fire was then swept out and dough was placed inside to bake. The ovens were left for the ages after the camp was abandoned, and one survives intact today. Also found here were rusty remnants of cans of blasting powder, which were used to remove the basalt from the grade.

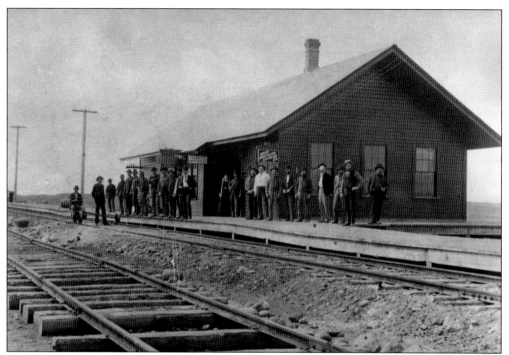

The Harrington depot was brand new in this 1893 photograph. There must have been enough potential business for the Great Northern to build a modest-sized depot like this. Note the man on the velocipede on the far left. This was an inexpensive way for one man to move along the tracks at speeds greater than by foot. (Courtesy of the Lincoln County Historical Society.)

The Hoyt-Delany grain warehouse at Lamona was typical of every other grain building in the Big Bend. It was designed to be able to store 50-pound sacks of wheat from the farm. The farmer making the delivery in the foreground manually sacked grain on his farm for delivery to the warehouse. Sacks were then loaded on boxcars for shipment. (Courtesy of the Odessa Historisches Museum.)

Odessa was platted in the summer of 1899 after the Great Northern Railway built its line through the valley in 1892. The siding there was named Odessa by railroad surveyors after the Russian city Odessa because of the German-speaking Russian wheat farmers in the area. This view dates to about the time the depot was built in 1900. (Courtesy of the Odessa Historisches Museum.)

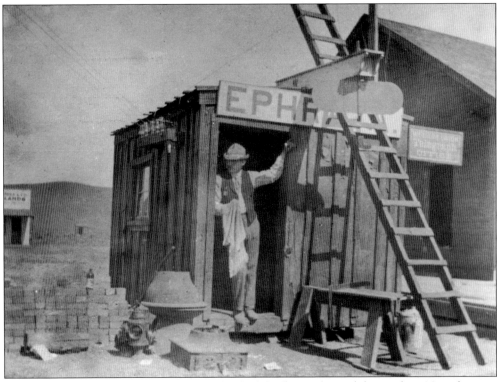

The first depot in Ephrata was a small affair but had the flavor of a much larger place. Note the train order signal (the elongated oval board hanging out over the door), which was a signal for trains to stop for orders. The line-side wires were connected directly to the depot. The replacement depot at right is nearly done; it opened in 1902. (Courtesy of the Grant County Historical Museum.)

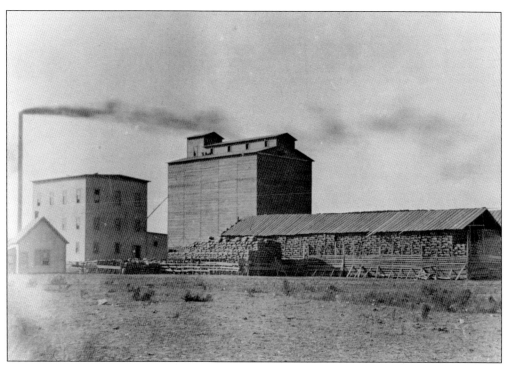

Flour mills were a sign of prosperity in towns with a railroad. This 1902 view at Odessa shows a flour mill in operation, with a grain elevator to the right of it connected via piping to the mill for easy transport of wheat. Note the large quantity of 50-pound sacks of wheat a few men are standing on to the right of the elevator. (Courtesy of the Odessa Historisches Museum.)

Irbydale was a bustling place in 1905, especially compared to today. In 1878, Ira Irby established Irby's Ranch here. The Great Northern built through the area, along Crab Creek, in 1892. Only remnants of the Hotel Irby, the building to the right of the one in the center of the photograph, remain. (Courtesy of the Odessa Historisches Museum.)

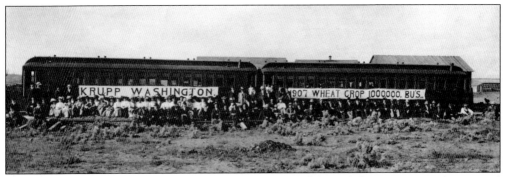

In 1907, Krupp raised one million bushels of wheat. It celebrated the occasion with a special train, seen here. The town officially incorporated in January 1911 and changed the name of the post office to Marlin during World War I in order to avoid negative German associations with the Krupp munitions works. (Courtesy of the Odessa Historisches Museum.)

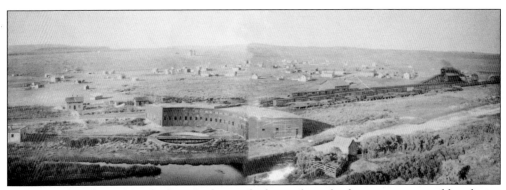

Wilson Creek is about 100 miles from Spokane, which was about the distance a train could go during a shift in 1893. This view shows the original roundhouse, which was removed in 1908. A new one was constructed in 1910. Wilson Creek ceased being an intermediate terminal in 1922, when the run was lengthened to Wenatchee. (Courtesy of the Grant County Historical Museum.)

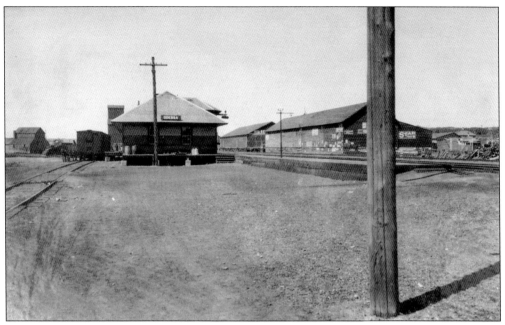

The Odessa depot in 1908 was still the center of the business district in town; everything needed was delivered or billed there. The train order board is sticking out from the right of the depot. Rules in effect at the time required that the board be placed in the "stop" position for 10 minutes after the departure of each train. (Courtesy of the Odessa Historisches Museum.)

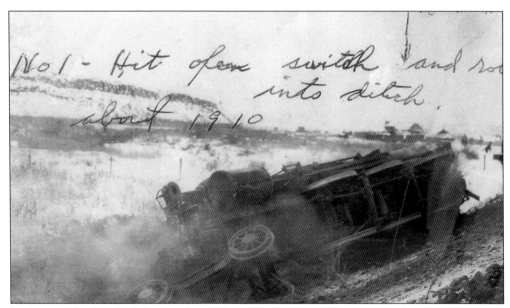

Looking at the details of this wreck at Wilson Creek, it seems the crew members were expecting the switch to be lined one way and were travelling fast enough that when they took the switch the wrong way, the locomotive was flung from the tracks. (Courtesy of the Grant County Historical Museum.)

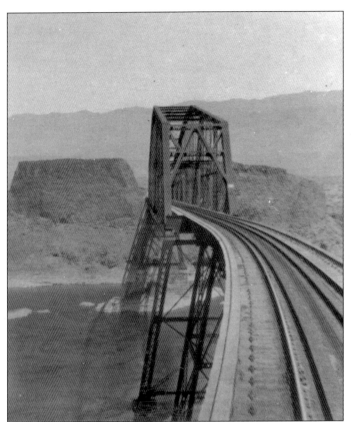

The bridge over the Columbia River near Rock Island took some time to build, so a ferry moved trains across the river near the Wenatchee railroad yard. The bridge was completed in 1892 and was used for years until the GN received some truly heavy steam locomotives in 1925 and needed to upgrade the bridge. Instead of rerouting traffic over a competing line or building an entirely new bridge, it simply constructed a new bridge around the current bridge, making it one of the most unique bridges in service today. The image at left shows what it looked like up until 1925. Below is a current view from the other side of the river. (At left, courtesy of Scott Tanner; below, Ross Fotheringham.)

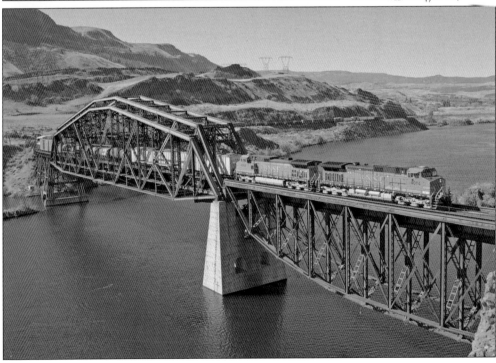

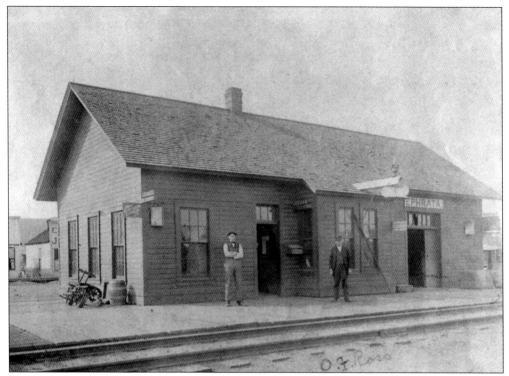

The 1902 depot in Ephrata was a marked improvement over the older one previously used. Note the velocipede to the left of the depot. (Courtesy of the Grant County Historical Museum.)

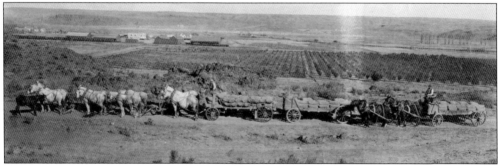

Wheat was still hauled via 50-pound sacks back in 1912. The destination for these farmers is the warehouses at Krupp, seen in the distance. Note the large orchards, no doubt irrigated from Crab Creek.

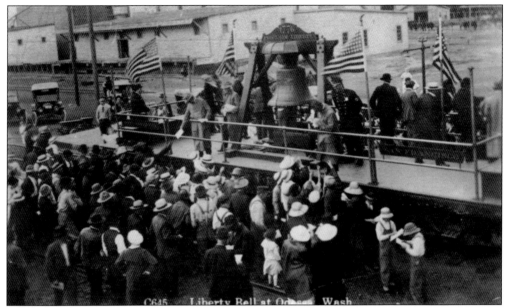

The Liberty Bell was sent from Philadelphia to San Francisco in 1915 to be a part of the Panama-Pacific International Exposition. It took a cross-country route via rail, making all sorts of stops just about anywhere. Here is the stop it made in Odessa on July 13, 1915. Crowds of all sizes turned out to view this piece of US history. (Courtesy of the Odessa Historisches Museum.)

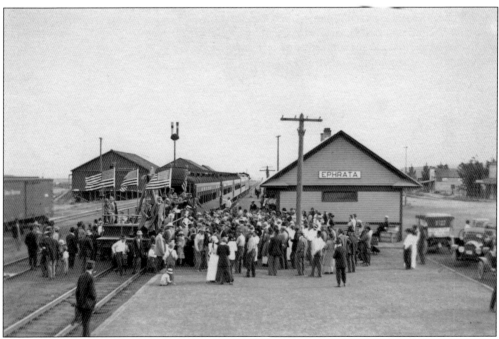

Here is the stop the Liberty Bell made in Ephrata that same day. (Courtesy of the Grant County Historical Museum.)

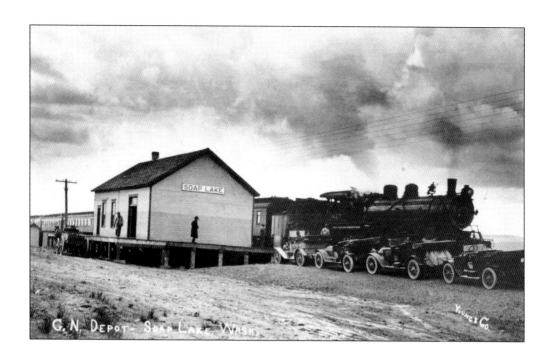

In the 1918 view above, train No. 39 is seen at Soap Lake. This train, and its eastbound counterpart No. 40, did not operate west of Leavenworth. People who wanted to do so had to make a connection at Leavenworth with other trains that operated to and from Seattle. Train No. 39 originated at Spokane and went through Soap Lake at 10:53 a.m., and No. 40 ran east through Soap Lake about 7:00 a.m. Those were the only daytime trains that stopped for passengers, though the fast mail train, No. 27, stopped around 7:00 a.m. The photograph below shows certain improvements that were made after 1923, such as the train order board. The depot burned down in 1944 and was replaced with a watchman's shanty from Columbia River station. (Above, courtesy of the Klausen family archives; below, the Odessa Historisches Museum.)

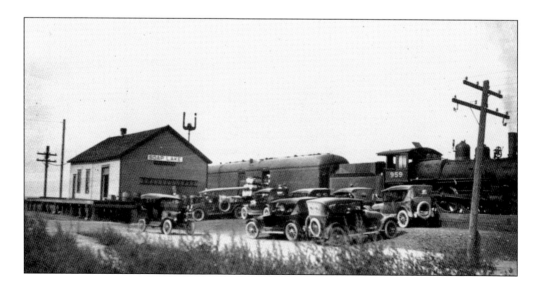

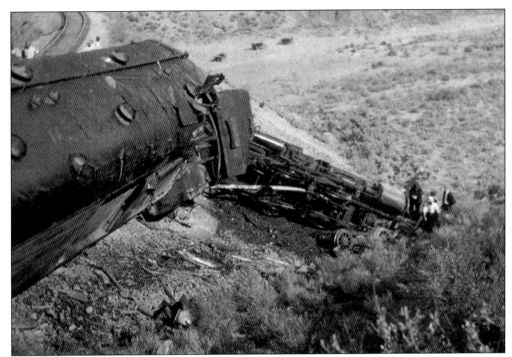

This 1917 view shows the result of taking a sharp curve near Crater station, located five miles west of Quincy, at a speed greater than allowed. An investigation of the accident concluded that signs warning "Slow" ahead of such places were insufficient for engineers to judge a proper speed, and signs with specific speeds soon replaced them. (Courtesy of Kristen Cormick.)

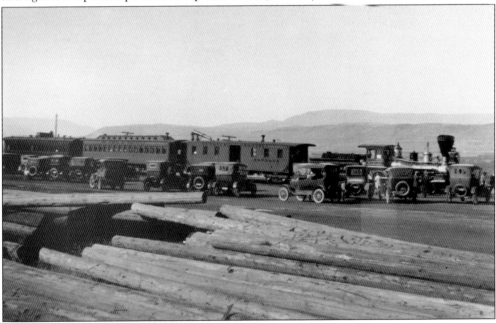

This ornate locomotive, named the *William Crooks*, toured the Great Northern in 1920 and was typical of the locomotives used in the early days of construction. The photograph was taken in Wenatchee near the location of the old depot. (Courtesy of the Odessa Historisches Museum.)

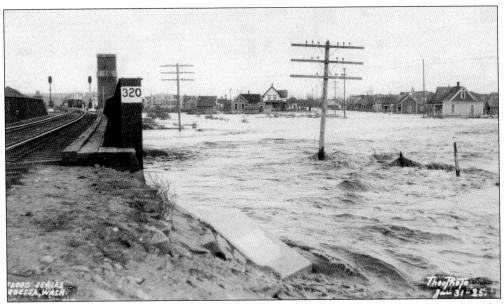

In January 1925, Crab Creek overflowed its banks after a midwinter thaw and nearly washed out the tracks at Odessa. The bridge number was changed by the 1950s to reflect the milepost location instead of being the 320th bridge from St. Paul. (Courtesy of the Odessa Historisches Museum.)

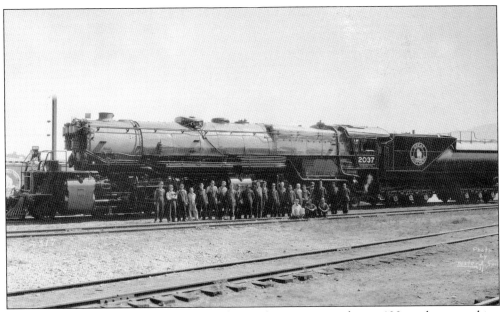

There was a 24-stall roundhouse at Wenatchee in the steam era with over 100 employees working there. The crew in this 1929 photograph has just completed repairs on the R-1 class 2-8-8-2, which was built at Spokane between December 19, 1927, and February 6, 1928. Assigned to the Spokane Division about the time this photograph was taken, it was retired in September 1955 and sold for scrap that November. (Courtesy of Dora Shirk.)

This view looks west toward what is now Nat Washington Way in Ephrata. The Shell oil distributor is on the left, and the Union oil distributor is on the right. The Union still had a railroad spur into it, which is just out of view to the right. All of the buildings in this scene are gone today, replaced with far newer construction. (Courtesy of the Odessa Historisches Museum.)

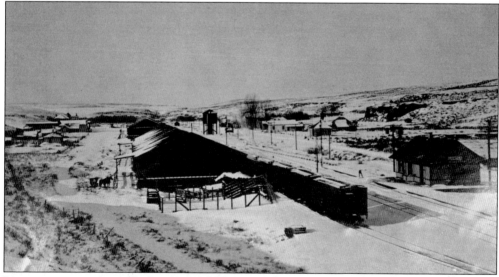

Lamona is seen sometime before 1940, which was when the depot was retired. Lamona was almost a bustling town of some significance. The only thing recognizable in this view today, besides the main line and industry track, is the building slightly obscured by the trees in the center. (Courtesy of the Odessa Historisches Museum.)

Shown here is Ephrata, looking south from the intersection of Alder Street and Third Avenue SW. The fence for the Shell oil facility is seen on the left. The signals along the tracks were upgraded in 2013, and this particular signal was removed, with a new one installed nearby. The signal project will also see the end of the railroad telephone pole line. (Courtesy of the Odessa Historisches Museum.)

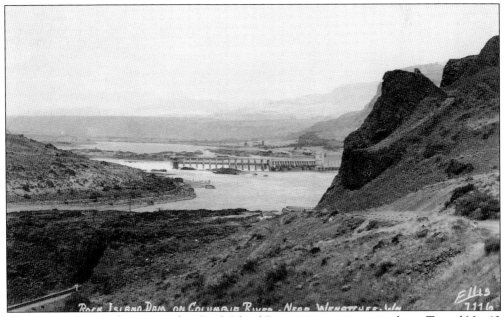

This postcard view of an incomplete Rock Island Dam is interesting, as it shows Tunnel No. 12 of the Great Northern. Drivers along the now paved highway on the right will note that today this is an open cut; the tunnel was "daylighted" in 1953.

This c. 1945 Great Northern Railway publicity photograph was taken just downstream of Rock Island Dam. The end of the train is probably still in Tunnel No. 12. One can see the scar for the highway on the hillside above the last boxcar. Note that the train is not moving—meaning the photographer got a good shot. (Courtesy of the Great Northern Railway Historical Society.)

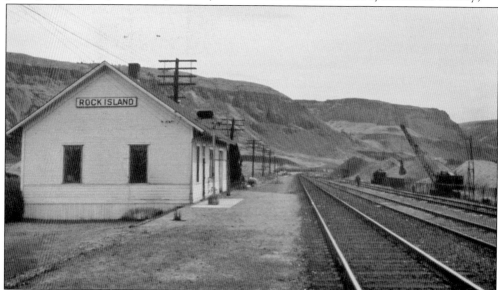

This depot was not the first here, as the prior one had been moved from Irby around 1930. That depot lasted until 1942, when the one pictured was built. On the left is part of the yard for the Keokuk Electro Metals site. The small industrial locomotive seen in the distance now sits in the Wenatchee Riverfront Park. (Courtesy of the Great Northern Railway Historical Society.)

TRAIN Nº	FROM	TO	DUE TO ARRIVE	WILL ARRIVE	DUE TO DEPART	WILL DEPART	REMARKS
EMPIRE BUILDER Nº31	CHICAGO	SEATTLE	2 01 AM		2 01 AM		West Bound
EMPIRE BUILDER Nº32	SEATTLE	CHICAGO	817 PM		817 PM		East Bound
WESTERN STAR Nº27	ST PAUL	SEATTLE	544 PM		544 PM		West Bound
WESTERN STAR Nº28	SEATTLE	ST PAUL	330 AM		330 AM		East Bound

DATE

This train schedule board once graced the interior of the depot in Ephrata. It was saved after the end of passenger service in 1971. At that time, Amtrak took over national passenger train service, and the *Empire Builder* was rerouted across the state via a different line. Service through Ephrata was restored in the 1980s.

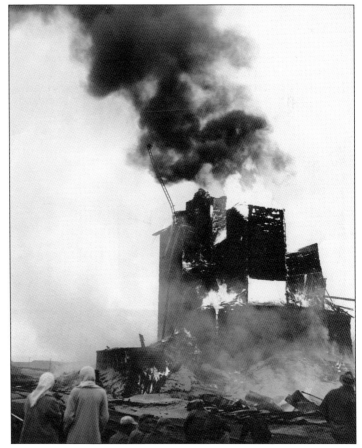

Ephrata lost some grain storage capacity in November 1958. Wheat dust can explode in the right conditions, and this is likely what happened here. Note all the wheat that has spilled from the elevator and the skeleton of the wood-sided boxcar. Fires like this also happened at Quincy, Odessa, and Lauer. (Photograph by H. Cliff Baughman, courtesy of the Odessa Historical Museum.)

When centralized traffic control was added to the railroad, the siding at Ephrata was skipped due to the public crossings that were normally blocked by waiting trains. When a three-way meet would occur, the local train would be stuffed onto the industry track, while a through freight would take the siding and the passenger train would come through.

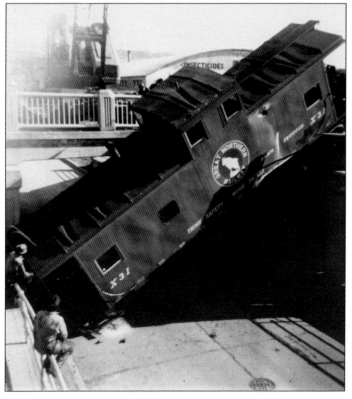

A little mishap occurred one Saturday night in October 1967. The caboose was shoved off the end of the caboose track and fell into the Thurston Street underpass that ran between the Railway Express building and the freight house/ yard office in Wenatchee. This building is immediately to the left, out of the photograph. The caboose was repaired and was in service for many more years. (Courtesy Dora Shirk.)

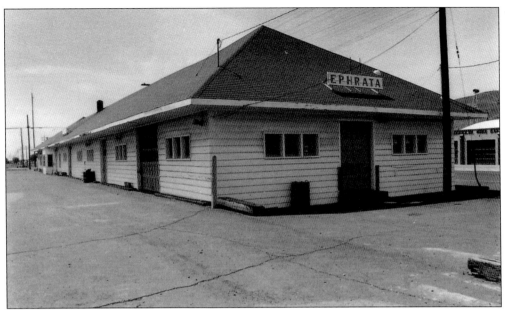

When originally constructed in 1902, this was a modest 24-foot-by-48-foot building. In 1912, it received a 30-foot-by-50-foot extension. One would not recognize it today from this photograph, as most of it was removed in 1983, leaving just part of the center section with the bay window intact. (Photograph by Norm Hochhalter.)

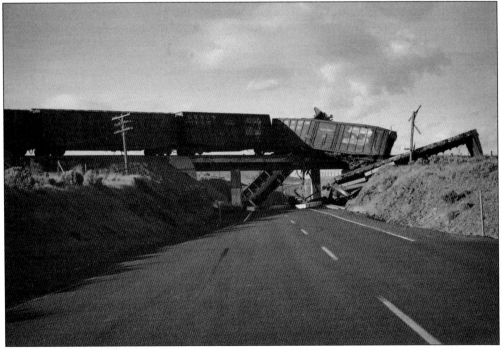

On Sunday, June 20, 1976, this train was traveling east of Odessa when a solid bearing failed on one of the railcars, causing the axle to break and the train to derail. Several cars fell off the tracks onto State Road 28 below. (Photograph by John A. Gahringer, courtesy of the Odessa Historisches Museum.)

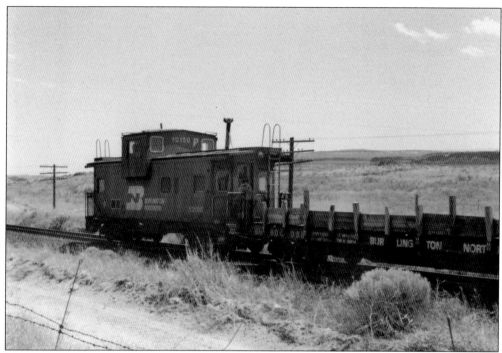

With railroad crew size reductions and the costs involved with hauling them around, a caboose at the end of the train was no longer common. Views like this one, outside of Wilson Creek in the early 1980s, are gone. (Photograph by Dorothy Kimball, courtesy Mike and Penny Kimball.)

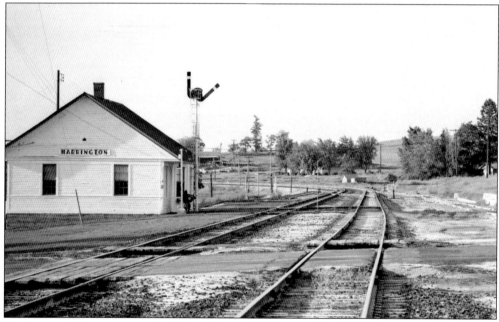

Harrington still sports a coat of ash from Mount St. Helens in July 1981. The Great Northern–built depot is also still standing in its standard Burlington Northern white paint with green trim, as are the signals of the train order board. This is in the middle of a stretch of double track, so both tracks are the main line. Now, only the tracks remain. (Photograph by S.L. Dixon.)

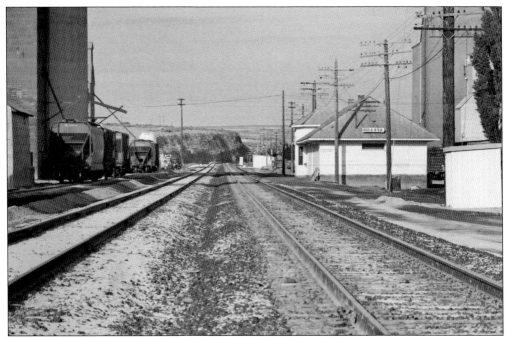

Odessa in July 1981 had the look of winter, courtesy of ash from Mount St. Helens. The town sported a slightly unusual depot, with the bay window extending above the roofline. Grain loading was still largely done in single-car lots instead of the unit trains of 26, 52, or 104 cars. Note the boxcar for grain loading just to the left of the depot. (Photograph by S.L. Dixon.)

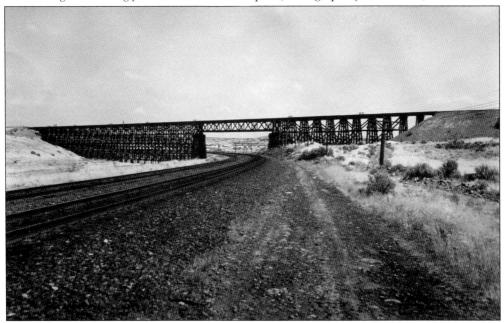

The large bridge at Adrian was removed in 1983. It was 723 feet long and towered 58 feet over Crab Creek. The two tracks under the bridge are the main line and siding of the Great Northern. There was an agreement between the Great Northern and the Northern Pacific to allow the NP to use the siding to access its small engine facility there.

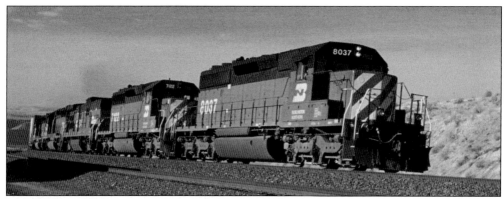

A Burlington Northern train grinds up the grade past the warehouse and grain elevator at Trinidad in 1994. This grade is part of a 1909 realignment that reduced curvature and grades between Quincy and Columbia River. If this train had been on the original 1892 grade, it would be up and out of this scene to the right.

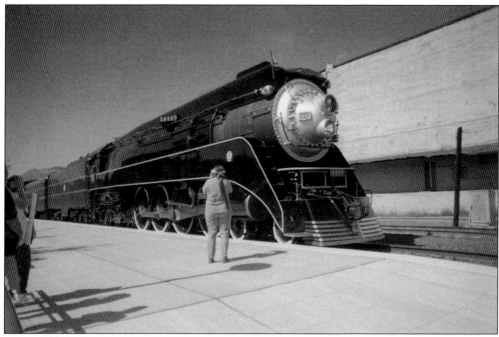

In July 2000, BNSF ran an employee appreciation special across the former Great Northern main line. At the location of the old depot in Wenatchee, this photograph of the steam engine used on the run was taken. This is the same engine used for the Washington Centennial Games in 1989 and was previously used on the *American Freedom Train*, which also passed through here.

In early 2012, BNSF started running loaded grain trains westward through the Big Bend and then over Stevens Pass. This mishap occurred at Wilson Creek due to a broken wheel. Nineteen cars were involved in the wreck, with eighteen of them shown here. After a few days, all of the cars had been shoved from the tracks, and the main line was repaired. All the cars were scrapped over the next few weeks, while the corn was reclaimed.

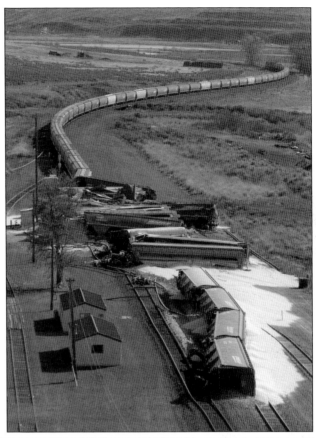

This rotary snowplow was built for the Great Northern in 1927. It is currently assigned to Wenatchee and is one of the few pieces of equipment on the BNSF to honor the heritage of one of the predecessor lines. The power to run the blade comes from an old locomotive converted to provide electricity just for the rotary.

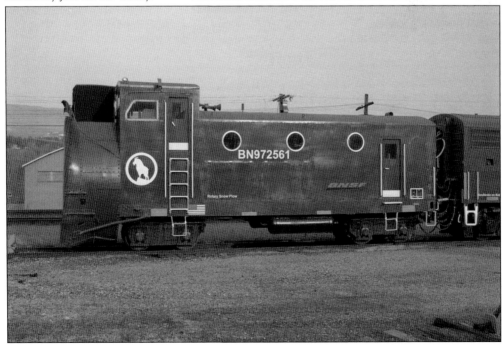

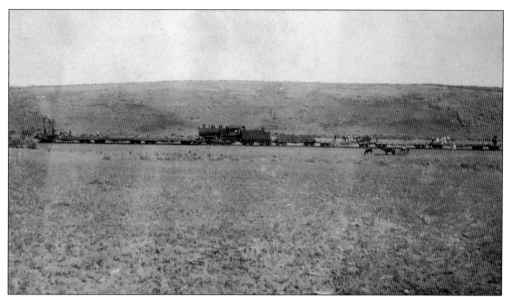

A work train is seen south of Douglas about 1909. The lead car is a track-laying car used to help move the rails into place. Note that there is no ballast between the ties. The steam locomotive, No. 1140, is part of the class of engines that typically worked the line through the end of the steam era in the early 1950s. (Photograph by Aaron Shimer, courtesy of Richard Karschner.)

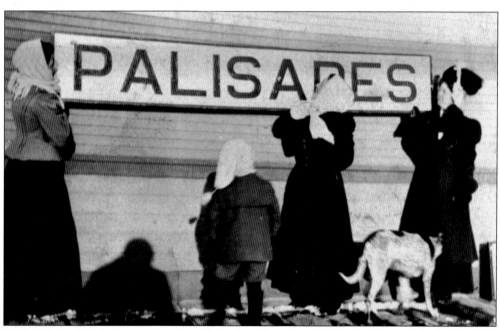

Having the railroad come to town was once seen as a sure way to know if a town would grow and be prosperous. The town of Palisades certainly had those thoughts when the Great Northern built the branch to Mansfield. Here, the town name is being placed on the depot. (Courtesy of Fran Roth.)

This is a piece of mail that was delivered during twice-daily mail service through the Railway Post Office. Train No. 381, of the Mansfield & Wenatchee RPO, delivered this postcard on November 10, 1914. This train was discontinued in January 1925.

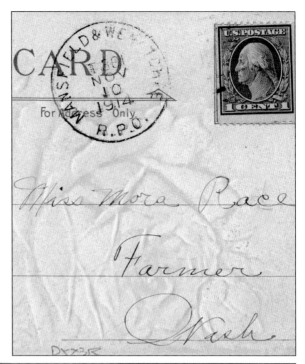

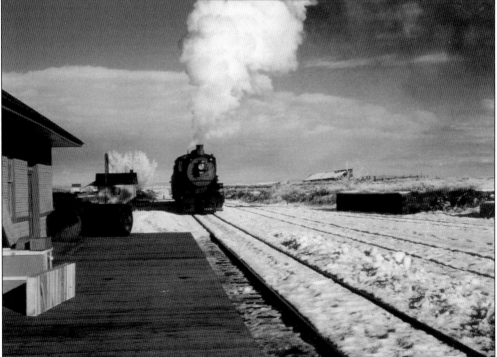

There was a wye at the end of the line at Mansfield used to turn steam locomotives. Here, No. 1147 has just been turned in 1947 for the return trip to Wenatchee. Of note is that this is the very steam locomotive on display in Wenatchee since May 21, 1956. (Photograph by Henry Gallaher, courtesy of Mary Ellen Wax.)

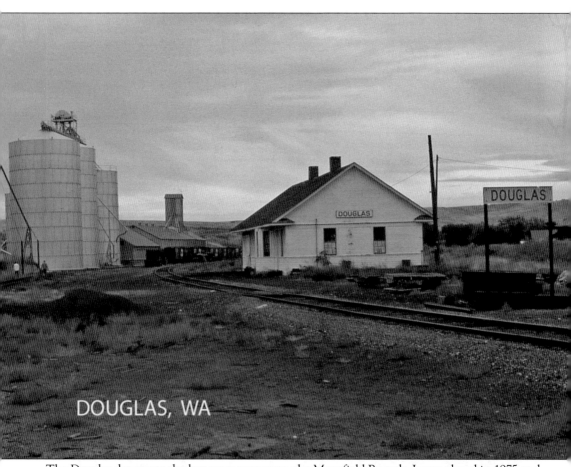

DOUGLAS, WA

The Douglas depot was the last open agency on the Mansfield Branch. It was closed in 1975 and was otherwise unused. Burlington Northern sold it to Central Washington Grain Growers not long after the line was abandoned in 1985. By 1994, it was deemed old and obsolete, so it was allowed to be burned down as a training exercise by the area fire department. The night before the fire, the station signs were removed for safekeeping. In the background, note the string of boxcars for grain loading in this 1983 view. The stack just in front of the end boxcar are grain doors used to mostly close the side door of the boxcar to allow it to be filled with grain through the upper portion of the opening. (Courtesy of the Great Northern Railway Historical Society.)

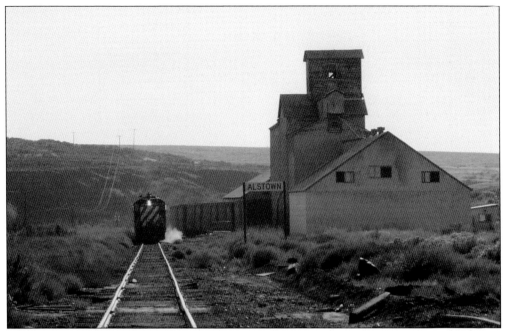

The train to Mansfield had left Wenatchee on October 28, 1983, to peddle the empty boxcars to stations along the line. Here, the train approaches from the south at Alstown just after the heaviest part of the climb up Moses Coulee. Note the string of boxcars next to the elevator that will be filled with grain. (Photograph by John P. Henderson, courtesy of Darrin Nelson.)

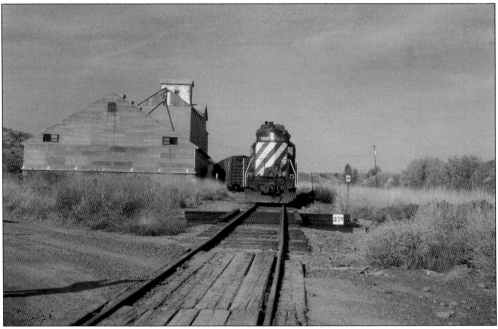

In this view looking north, the train is running past the boxcars spotted at Alstown as it heads south to the next station of Douglas on October 28, 1983. Bridge No. 37.5 can be seen in the foreground, as well as the road that is still in use today. (Photograph by John P. Henderson, courtesy of Darrin Nelson.)

The mouth of Moses Coulee provides wide-open vistas where a long train of empty boxcars seems like a model. The train is seen looking south as it passes the siding switch to Bonspur, where there was a line to access the big electrical substation to the right near the Columbia River. Loads such as transformers were delivered here by flatcar. (Photograph by John P. Henderson, courtesy of Darrin Nelson.)

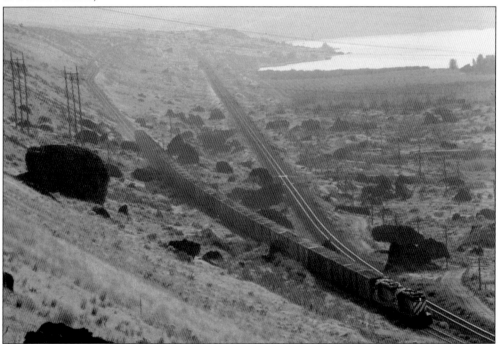

A train of boxcars filled with grain comes down the grade and will rejoin the main line at Columbia River to complete the journey to Wenatchee. This grade was originally the main line, which was relocated in 1900 between Columbia River and Quincy. The branch utilized the old grade to a point where it veered left and followed Douglas Creek into Moses Coulee. (Photograph by John P. Henderson, courtesy of Darrin Nelson.)

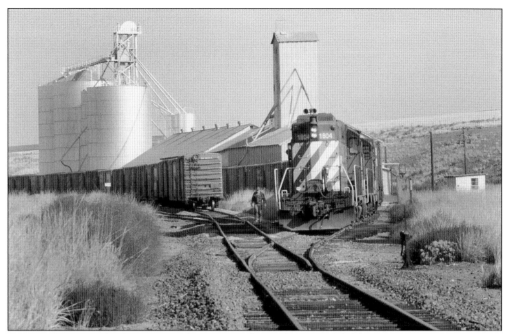

Prior to being washed out 1948, the Waterville Railway would deliver boxcars of grain from Waterville to Douglas. This 1983 photograph of Burlington Northern operations was taken 13 years after the Great Northern ended. The Waterville Railway assets were absorbed into the local grain co-op in 1976. In 1985, this line through Douglas was abandoned as well. (Photograph by John P. Henderson, courtesy of Darrin Nelson.)

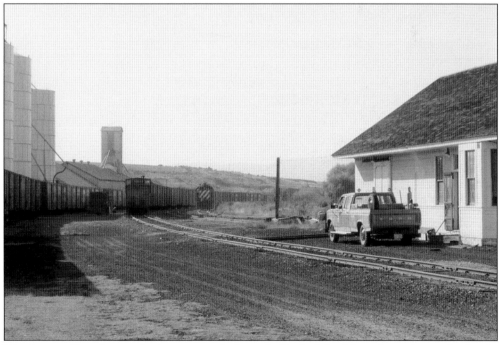

The depot at Douglas was the last one on the branch. To the left of the caboose is a stack of grain doors. (Photograph by John P. Henderson, courtesy of Darrin Nelson.)

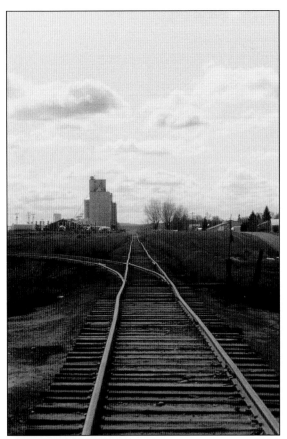

One of the legs of the Mansfield wye can be seen curving to the left. In this 1983 view looking south, the poor condition of the track indicates that it was not used much with diesel locomotives. At one point, the GN proposed extending the branch all the way to the site of Grand Coulee Dam to haul in construction supplies. (Photograph by John P. Henderson, courtesy of Darrin Nelson.)

Grain-loading boxcars and the tall cliffs and hanging valleys of Moses Coulee are a unique combination only found on the Mansfield Branch. This line also boasted grades normally found going over the mountains, so the crews had to be careful coming back down the coulee with the heavy grain trying to push them all the way. (Photograph by John P. Henderson, courtesy of Darrin Nelson.)

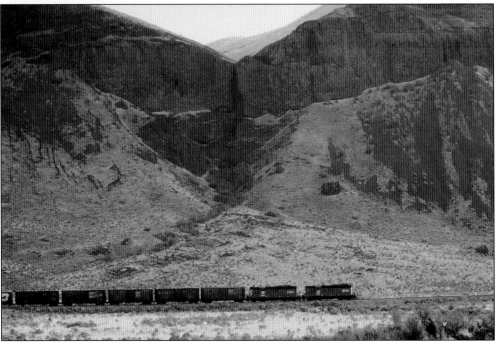

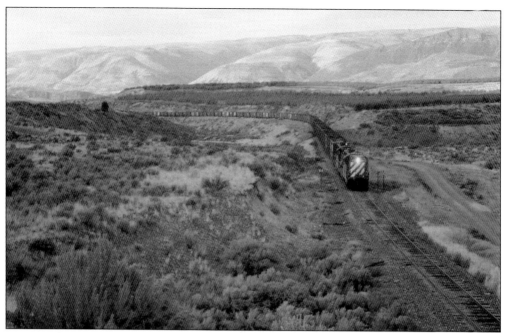

Many readers will recognize this location, where State Route 28 crosses Douglas Creek near the mouth of Moses Coulee. The train has recently left the main line, climbed into the coulee, and is headed up the line to peddle the boxcars to the waiting grain elevators. The grade through here is now part of a private access road for the neighboring orchards. (Photograph by John P. Henderson, courtesy of Darrin Nelson.)

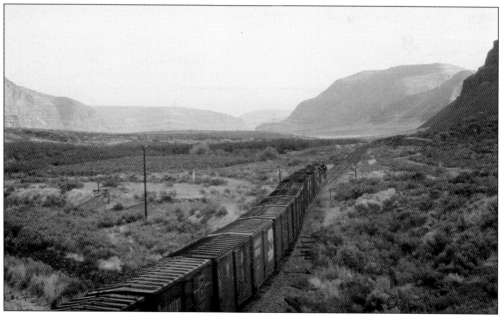

The train has now crossed underneath the highway, and one can see a nice cross-section of boxcars from the railroads that merged to form Burlington Northern in 1970. Looking closely, one can see the crossbucks marking the road crossing; one of these crossbucks is now on display at the museum in Mansfield. (Photograph by John P. Henderson, courtesy of Darrin Nelson.)

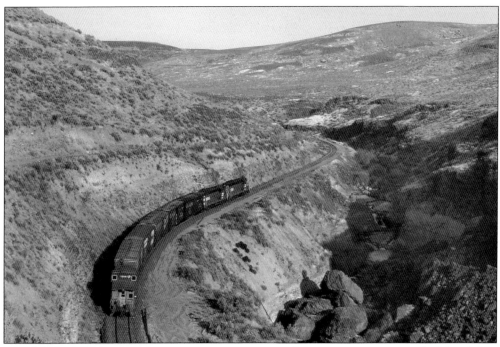

A few cars are in tow as the Mansfield Branch train makes its way upgrade near McCue. After the line was abandoned in 1985, the portals of the tunnel here were sealed. In 2000, some of the tunnel lining failed, resulting in a 10-foot-diameter sinkhole. (Photograph by John P. Henderson, courtesy of Darrin Nelson.)

Milepost No. 1 of the Mansfield Branch still sits above the current BNSF main line near Columbia River/ Albus. The sign still marks the first mile of the branch, which has not seen a train in nearly 30 years.

```
UUX01 P45 P45 509218B003
O.T.H. F802200  ** VIA C@@ - FILE @@ **
F602200 0020 1248 03/01/85 U535
****TASK ZZ K202044  K202044  DAS N601 ZZ
WEA WC DS WENATCHEE WA MARCH 1 1985
JW ISENBERG, KL MAZE, R ROY SPOKANE SPF-3
KR IVERSON, TRICK DISPATCHER A, SPOKANE ACD SEATTLE SEC-3
CONDUCTOR AND ENGINEER DOUGLAS TURN SAT MARCH 2 1985

WILL RUN A DOUGLAS TURN ON THE MANSFIELD LINE SATURDAY
MARCH 2, 1985.  CALL TRAIN FOR 5AM WITH POWER ARRIVING FROM
THE WO TURN.  WENATCHEE WILL FURNISH ENGINE CREW, CONDR
AND TWO BRAKEMEN FROM COMBINATION BRD.  TWO UNITS

GO CABOOSE HOP FROM WENATCHEE TO DOUGLAS.  EVERYTHING AT
DOUGLAS COMES OUT.  GATHER UP YOUR TRAIN AND MOVE TRAIN SO
ENGINES ARE AT DOUGLAS DEPOT AT 10AM.  PARTICIPATE IN
CEREMONY COMMEMORATING LAST TRAIN OFF MANSFIELD LINE.  THEN
DEPART FOR WENATCHEE WITH 41 LOADS OF GRAIN.
CALL SECTIONMAN RICK COGGINS 662-8370 WHEN TRAIN DEPARTS
SWITCH 1 APPLEYARD ON OUTBOUND TRIM       T-103-1  F.C. BROSE
END
```

This company message shows the running instructions issued to the last train to run on the Mansfield Branch. The message was addressed to the dispatcher who handled the territory between Seattle and Harrington, which included this line. The locomotives had just completed the run on the "WO Turn," which was the run from Wenatchee to Oroville, and men to run the train were drawn from the crews laying over at Wenatchee. "Caboose hop" meant it was to run from Wenatchee to Douglas with just a caboose. The rest of the description is easy to follow, as it was to pull all remaining cars off the line and stop for a ceremony marking the last run. (Courtesy of Dave Sprau.)

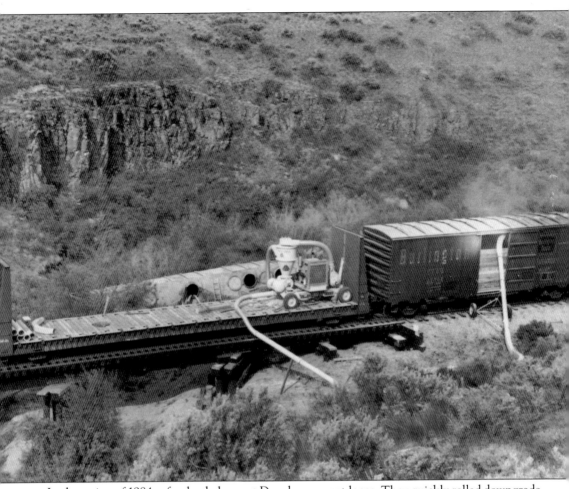

In the spring of 1984, a few loaded cars at Douglas were set loose. They quickly rolled downgrade to about a mile beyond Alstown before the first one left the rails; the other two soon followed. Within a short time, crews were out cleaning up the mess with an industrial-sized vacuum. Here is the second crash site near Bridge No. 36, showing the wreck behind the vacuum. Note the grain door in the boxcar. (Photograph by Dennis Viebrock.)

Three

THE MILWAUKEE ROAD

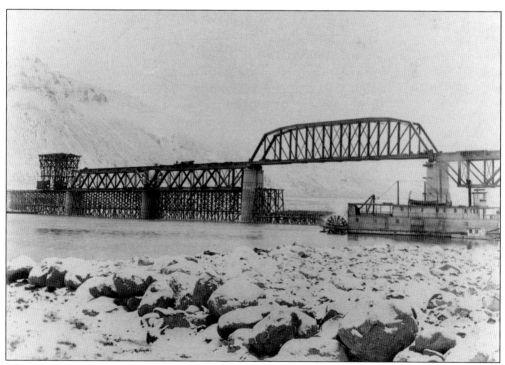

The steamboat *St. Paul* was used by the railroad to haul bridge-building supplies from the Great Northern station upstream at Vulcan to Beverly, where the mile-long bridge over the Columbia was being constructed. (Courtesy of the Othello Community Museum.)

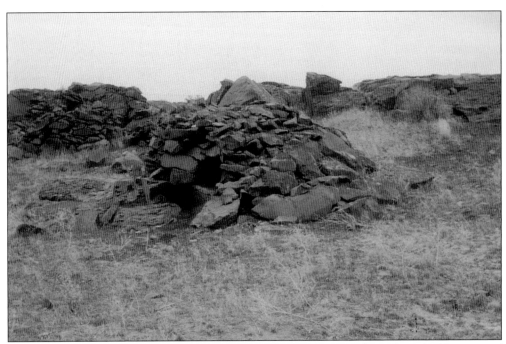

This view shows an oven on the west side of the Columbia River Bridge at Beverly. (Courtesy of the Othello Community Museum.)

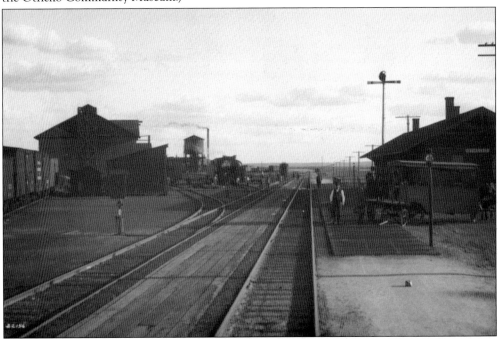

At Othello, the tracks curving off to the left lead toward the roundhouse area, near the water tank and smokestack. The large building on the left is the old icehouse, which burned down. The photographer is standing on the rear platform of an eastbound passenger train. The depot was without electric power for some time, even after the line was electrified. (Photograph by Asahel Curtis, courtesy of Allen Miller.)

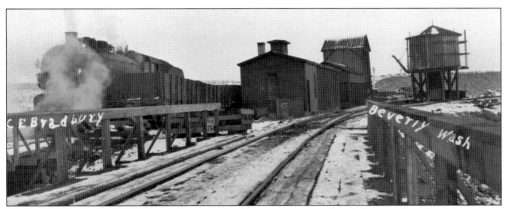

The facilities at Beverly were in keeping with a mountain railroad, being that the 2.2-percent grade headed west was just on the other side of the Columbia River Bridge. Steam engines were not rated for much hauling ability on this grade, so when electrification was installed in 1919, the amount a train could take up the hill was greatly increased due to its better ability. The wye was installed here about 1908 because, until the bridge across the Columbia was completed, Beverly was the end of the line for any train movements from the east. It then was used to turn the steam-powered helpers and, after 1913, the steam power used on the Hanford Branch. Beginning in 1919, after electric boxcabs were used as helpers, which were double-ended units, the wye remained solely for turning the steam, and later diesel, power working the Hanford Branch. (Courtesy of Mike Denuty.)

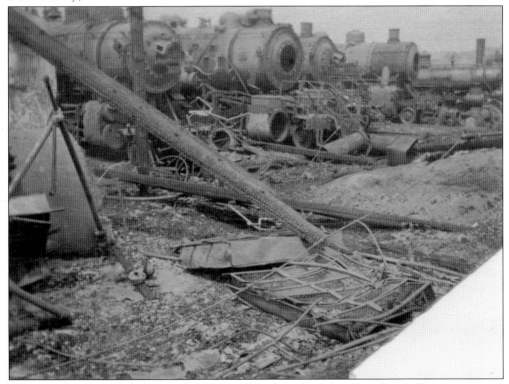

The roundhouse in Othello caught fire in 1919 after a Fourth of July baseball game in town. The building was a total loss, as were eight steam engines. The roundhouse was rebuilt as a brick building. (Photograph by Lylah Hodson, courtesy of the Othello Community Museum.)

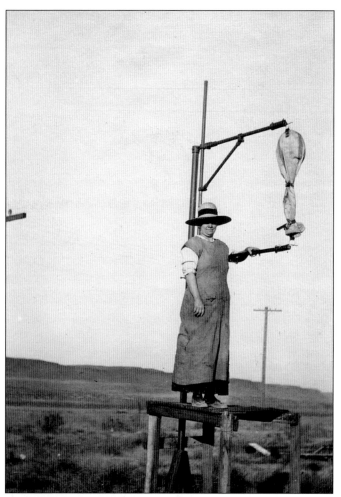

A Mrs. Young stands on the platform to place the mailbag on the mail crane at Smyrna in 1918. Placing the mail this way allowed it to be picked up by the train without stopping. A bag would be thrown off the train in return. For a period of time, mail for Smyrna and points around it were dispatched daily except for Sundays and holidays. (Courtesy of John Ball.)

On July 24, 1919, the Corfu depot caught fire when the embers from a locomotive landed on the roof. The operator had just enough time to tell the dispatcher that the depot was on fire, and he barely got out. The agents lost everything they had in the depot's living quarters. Even the water hose outside on the lawn burned up. (Photograph by Leah Carrell, courtesy of Allen Miller.)

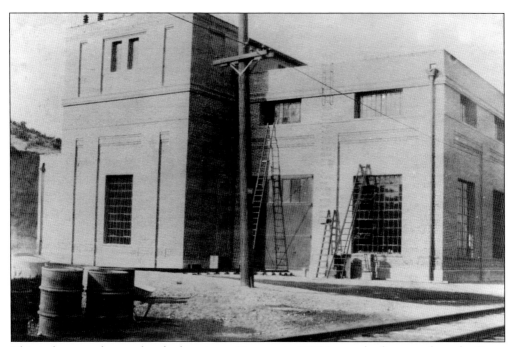

This is the recently completed substation at Taunton in 1919. It was the first one along the Coast Division outside of Othello. Commercial power was supplied to the substation at 100,000 volts AC and then converted to 3,000 volts DC via motor-generator sets inside the building. The power was then transmitted to the overhead wires above the tracks for the electric locomotives to use. (Courtesy of the Othello Community Museum.)

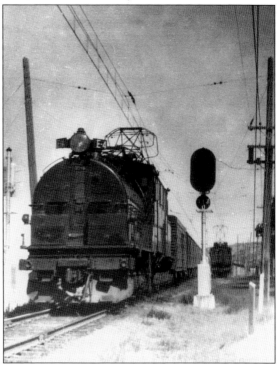

A Milwaukee Road passenger train passes a waiting freight train at the siding of Taunton. The E-4 is one of five "Bipolar" types. This made the axle the motor armature, resulting in no gears and making for a quieter locomotive. These were used on passenger train runs from Tacoma to Othello and came to symbolize the railroad during their nearly 40 years of use. (Courtesy of Allen Miller.)

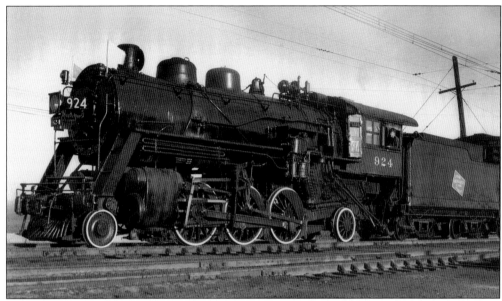

No. 924 was a class K-1 Prairie-type 2-6-2, built by Alco in August 1908 as the Chicago, Milwaukee & Puget Sound No. 2040. This class of steam engine was normally assigned to the run to Hanford. It was routinely serviced at Othello. (Photograph by Wade Stevenson, courtesy of the Othello Community Museum.)

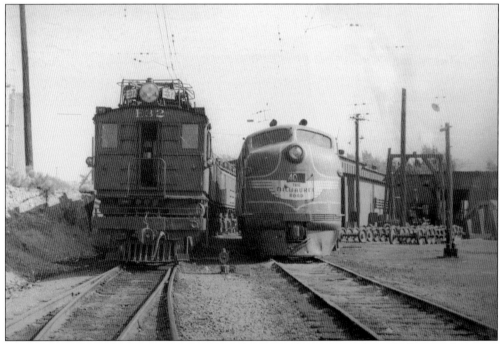

The Milwaukee Road FT No. 40 was state of the art in this scene at the Othello roundhouse in 1941. Next to it is E32, which was also state of the art when it was built in 1915. Both locomotives used electricity to move, but No. 40 was self-contained, while E32 relied on a series of overhead wires and substations. No. 40 was traded in for new locomotives in 1959, while E32 served until 1965, when it was scrapped. (Photograph by Gayle Christen, courtesy of Allen Miller.)

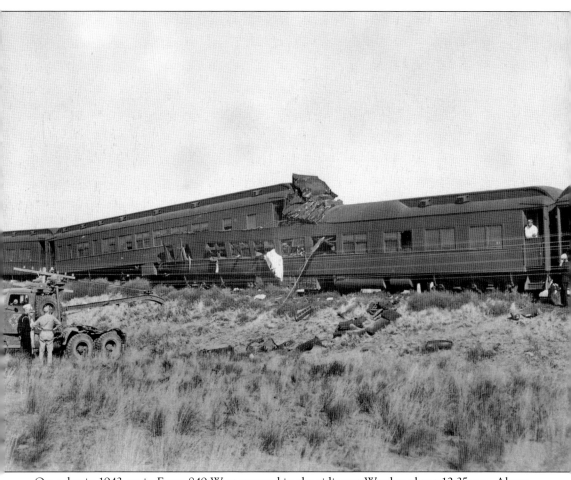

On a day in 1943, train Extra 849 West stopped in the siding at Warden about 12:35 a.m. About 17 minutes later, after this train had moved westward on the siding and stopped, the engine fouled the main track on the turnout of the west switch. While this train was moving in backward motion in an attempt to clear the main track, Passenger Extra 251 West struck the engine. Under the rules, Extra 849 was required not to pass the west siding-switch until after the switch had been in open position at an interval of two minutes. As Passenger Extra 251 was approaching Warden, the speed was about 55 miles per hour. The first warning the crew had of anything being wrong was when their engine reached a point about 1,000 feet east of the west siding switch, and they saw stop signals being given from a point about 130 feet in the distance. The engineer hit the brakes but could not stop his train short of Extra 849. Miscommunication of orders for Extra 849 was the cause of the accident. (Courtesy of the Othello Community Museum.)

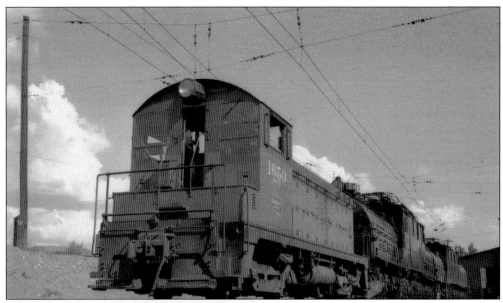

No. 1650 is shown pushing two Bipolars into the service tracks at the Othello roundhouse. No. 1650 was an EMD NW-2 1,000-horsepower diesel switcher. They started out life in a basic black scheme but were painted into this orange and gray, with a maroon stripe, after a couple of years. (Photograph by Wade Stevenson, courtesy of the Othello Community Museum.)

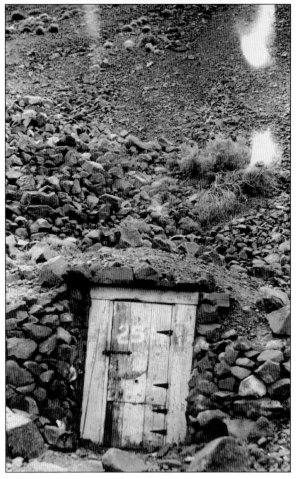

The ice cave near Jericho came about when the Milwaukee Road first surveyed here in 1906 and workers discovered ice on the ground at the base of the mountain. They excavated a chamber about 10 feet into the hillside and installed wooden beams to support the roof. Though the cave was dynamited closed, one can still feel unusually cold air in that area. (Courtesy of Dave Morgan.)

Charles Davidson, the roundhouse foreman in Othello, checks No. 251 at the roundhouse. Steam was largely used on the section of tracks from Avery, Idaho, to Othello. At Othello, the steam engines were switched out for electric locomotives. No. 251 was the only 4-8-4 type locomotive constructed by the railroad, others having been constructed by commercial builders. (Courtesy of the Othello Community Museum.)

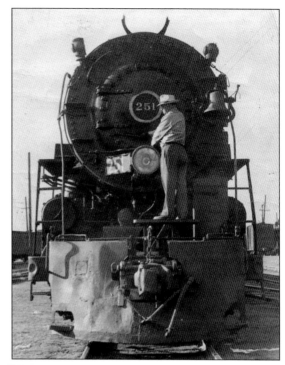

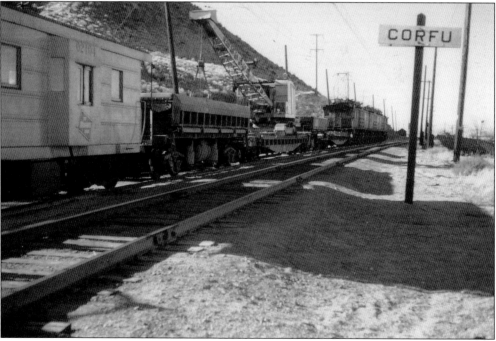

In 1951, a work train, pulled by the Milwaukee's distinctive boxcab locomotives, passes Corfu on its way to a repair job. The caboose, with its distinctive horizontal ribbing, was one of many built by the Milwaukee in its own shops. As for Corfu, only the main line exists here now, not having had any trains pass by for a few decades. (Photograph by Wade Stevenson, courtesy of the Othello Community Museum.)

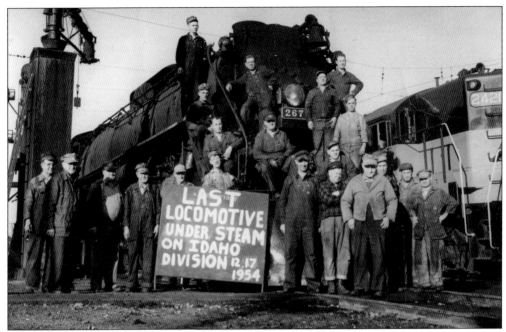

The Idaho Division, the nonelectrified segment between Othello and Avery, Idaho, was the first to be assigned diesel locomotives for freight service in the 1940s. As diesels were able to make better time over the division, its capacity was increased since they did not have to stop for water and coal periodically. (Courtesy of the Othello Community Museum.)

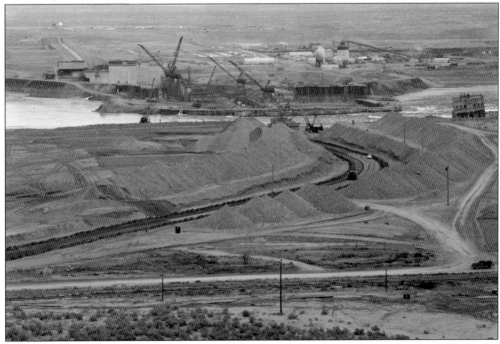

This December 1957 view shows the construction of Priest Rapids Dam near the railroad siding of Priest Rapids on the Hanford Branch. Note the new railroad spur to allow construction materials into the site. (Courtesy of the Grant PUD Archives.)

It is well known that the wind blows at Beverly. There were instances of railroad cars being blown off the bridge, so a wind speed indicator was set up to alert trains when the winds were too high to cross the bridge. However, they were so strong in 1958 that some of the cars in the Beverly yard were blown off the track. (Courtesy of the Othello Community Museum.)

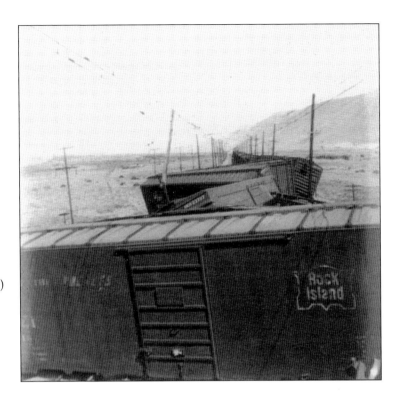

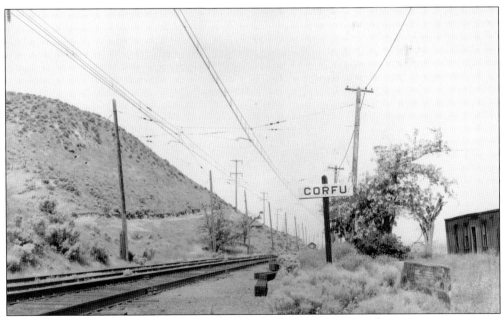

A vice president of the Milwaukee Road, who also bestowed many other names on points in eastern Washington, named Corfu. It was named for one of the large islands off the mainland of Greece. The building on the right, in this July 1965 view, is a converted boxcar, likely used as the agent's quarters after the depot and living quarters burned down in 1919. (Courtesy of the Othello Community Museum.)

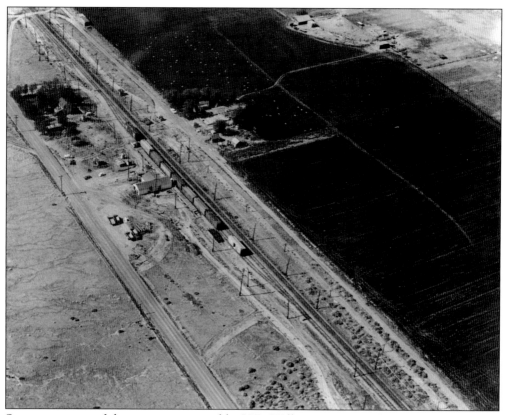

Smyrna was one of those stations named by H.R. Williams, vice president of the Milwaukee, who gave European and historical names to a number of places along the line. Note the little shed across from the top car; it was used for storing two speeder cars. The house nestled in the shade of the trees may very well be the section foreman's house. (Photograph by Robert McCoy, courtesy of Nate Molldrem.)

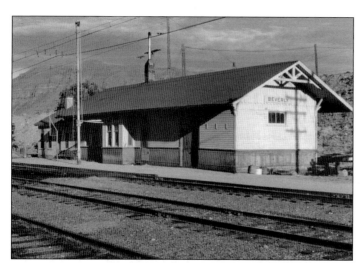

Because the train order signal is missing the semaphore blades, this photograph of the Beverly depot was taken in the brief period between the time when the depot was closed as an agency (1968–1969) and when it was reopened as a train order office at the end of August 1971. (Photograph by Clarence Rasmussen, courtesy of the Grant County Historical Museum.)

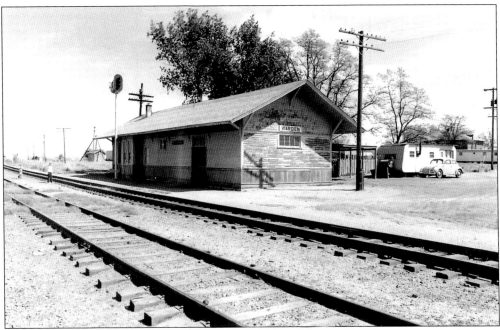

The 1973 photograph above shows the Warden depot in its original location next to the tracks. It was built to the Milwaukee Road "Class A" depot plan; Marcellus and Moses Lake were extended and slightly modified versions of this depot. Warden was 24 feet wide by 76 feet long, the standard depot size being 24 feet by 44 feet with varying freight room lengths; Warden's freight room was 32 feet long. The depot contained basic living quarters for the agent and his family. Warden was the junction for the branch to Moses Lake and Marcellus. It was closed on May 27, 1975, and the agent was bumped onto another agency. The depot survives today, located a few blocks away, as a museum. (Both photographs by Norm Hochhalter.)

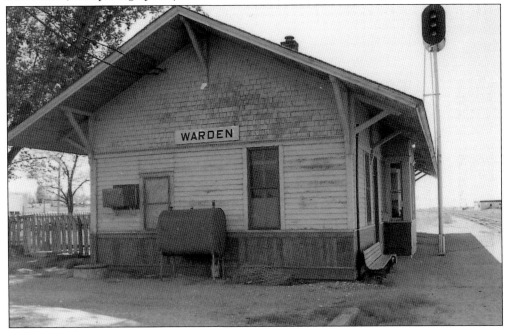

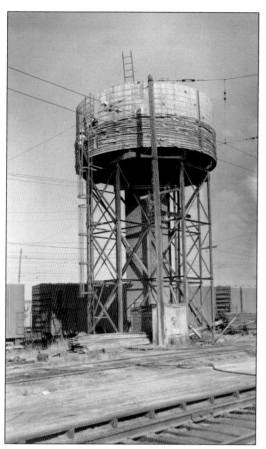

The water tank in Othello was no longer needed by the railroad or the city by the 1970s and was carefully torn down to salvage the wood. The refrigerator cars on the track are for the frozen french fry business that boomed in Othello, which it still does today. (Photograph by Wade Stevenson, courtesy of the Othello Community Museum.)

The E-39 set of boxcab electric locomotives has coupled onto a westbound freight at Othello in 1973. An electrical supervisor for the Milwaukee, Lawrence Wylie conceived a device that allowed a diesel locomotive to be operated in unison with an electric boxcab set; it was known as a "Wylie throttle." It easily allowed the electrics to continue to be used on through trains. (Photograph by Norm Hochhalter.)

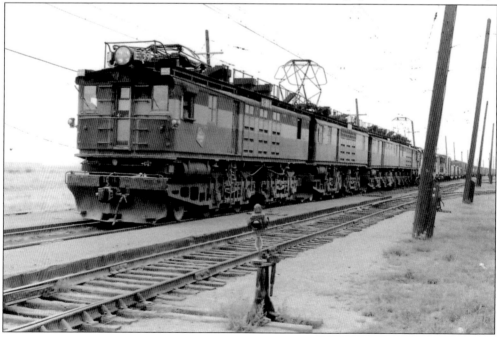

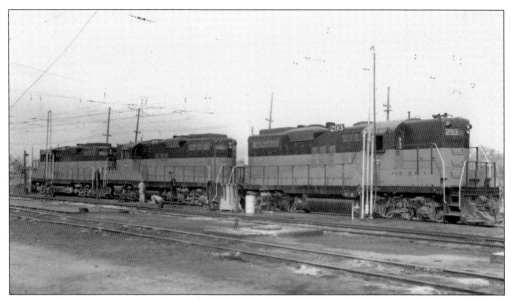

Three GP9s are getting inspected at Othello in 1973. At this time, the catenary for electric locomotives was largely in place, though only diesels were being used. (Photograph by Norm Hochhalter.)

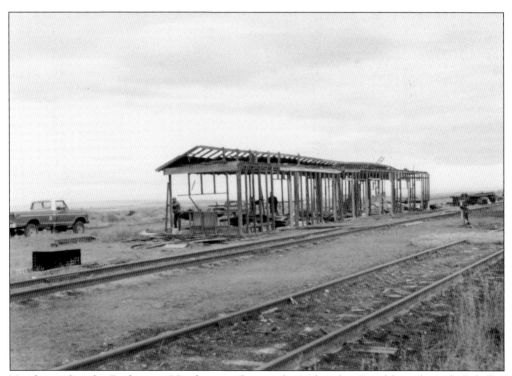

Not long after the Burlington Northern took over the Milwaukee Road line through Othello, the depot was torn down after just about everything else railroad related. Here, the demolition crew is salvaging the wood from what was once the center of railroading in town. (Photograph by Wade Stevenson, courtesy of the Othello Community Museum.)

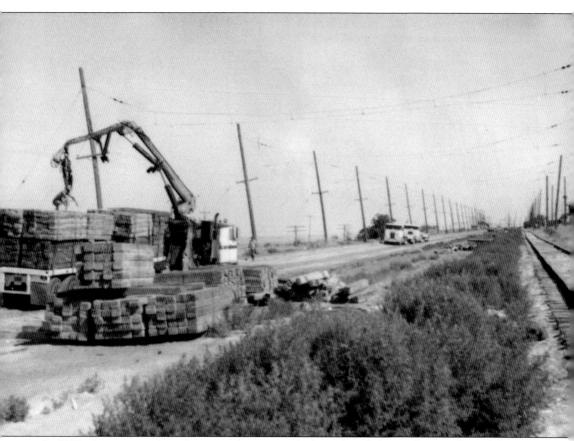

In 1980, the extra yard tracks were taken up, with the rail and the ties being salvaged for later use. A few through tracks were kept to allow what little business there was in town to continue. Above the tracks are the remaining supports for the old electrification system, last used in 1971. (Courtesy of the Othello Community Museum.)

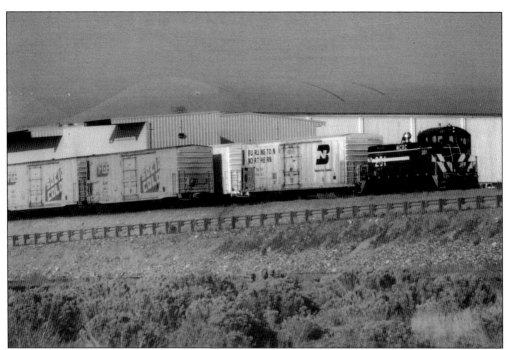

The Burlington Northern bought the Milwaukee Road main line from Warden to Royal City not long after the Milwaukee abandoned the lines west of Terry, Montana, in 1980. After running them for six years, the BN sold off the lines to short-line start-up Washington Central. Here is one of its switchers moving cars at the frozen french fry plant in Othello about 1990. (Courtesy of the Othello Community Museum.)

Not long after the Milwaukee Road abandoned its lines through the area in 1980, the track was reclaimed for reuse. Here is the old yard area at Beverly looking like a shadow of its former busy self. The depot is the farthest building in the distance. (Photograph by Wade Stevenson, courtesy of the Othello Community Museum.)

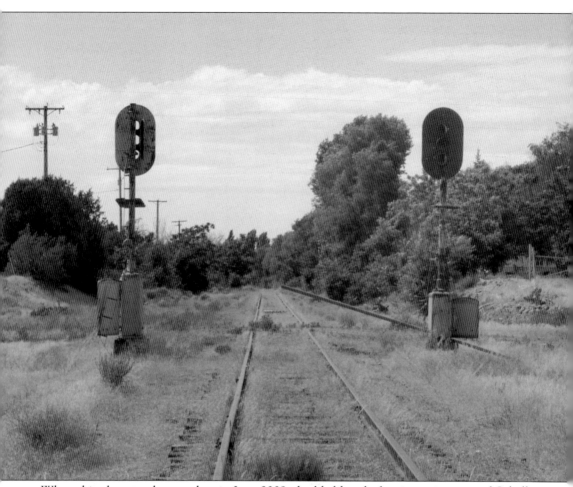

When this photograph was taken in June 2009, the likelihood of seeing trains west of Othello seemed grim. Port of Royal Slope, looking to restore service to Royal City from Othello, took it upon itself to clean up the tracks and fix parts of the line and is now waiting for an operator of the line to be named.

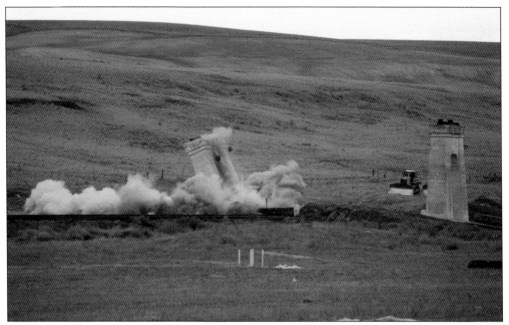

There used to be a very large bridge at Lind, where the Milwaukee Road crossed over the Northern Pacific and successors. Monte Holm of Moses Lake scrapped it in 1981. These two concrete pillars have stood as silent sentinels since that time. In 2014, BNSF needed room for a second main line, so it blasted one of the pillars to clear the way.

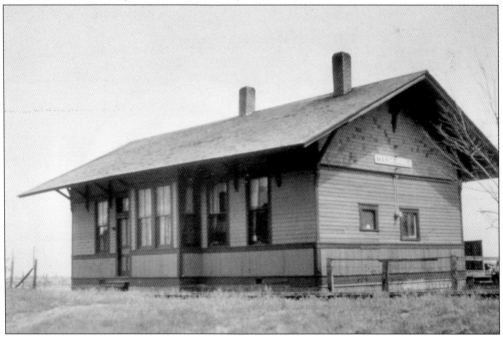

The depot at the end of the "Wheat Line" at Marcellus was a lonely spot, located north of Ritzville by about seven miles. It was similar to the one in Moses Lake, save for being shorter by not having a baggage room. All that is left today is the elevator. (Photograph by Wade Stevenson, courtesy of Allen Miller.)

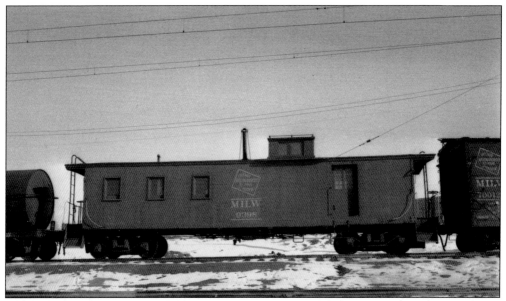

This is the regularly assigned caboose to the trains that served the Moses Lake and Marcellus Branches in 1949. Known as a side-door caboose, these were common on branches that had eliminated their regular passenger trains but wanted to still accommodate a small, but necessary, ridership among mostly male patrons. (Photograph by Wade Stevenson, courtesy of the Othello Community Museum.)

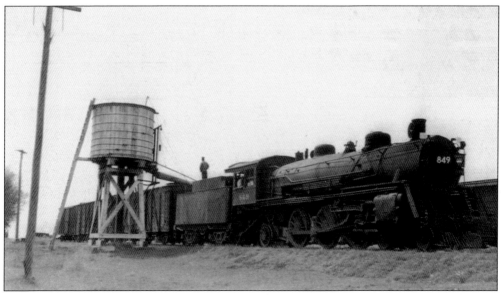

The engineer had to make a stop for water at the tank at Marcellus on May 8, 1952. The size of the tank here is quite small, as it was built to only fill one locomotive a day. No. 849 was built for the Chicago, Milwaukee & Puget Sound as its No. 3120 and was retired from service four months after this photograph. (Courtesy of the Othello Community Museum.)

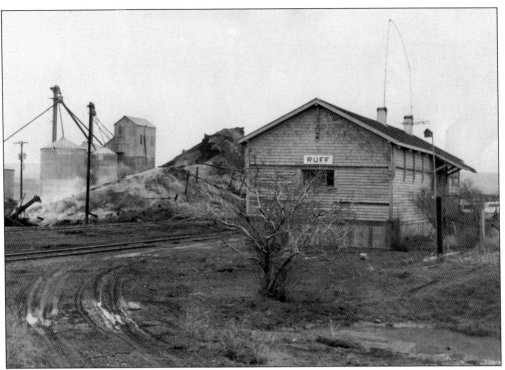

The Ruff depot had seen better days when this early-1970s photograph was taken. It closed as an agency in June 1933 and was converted into a dwelling for the section foreman sometime later. This depot was built without a freight room, but one was added later. The freight room ruined the look of the building when the roof overhang was sawed off and the brackets removed. (Courtesy of the Odessa Historisches Museum.)

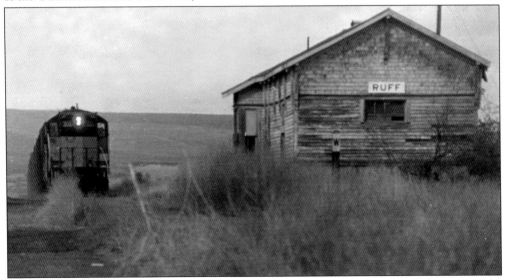

This Moses Lake Branch was served regularly with assigned power from Othello because of the business out at the air base and the Utah-Idaho Sugar plant at Scalley, and a side trip was made, as needed, on the Marcellus line. Boxcars of wheat are passing the depot at Ruff on their way to the main line at Warden. (Photograph by J. Foust, courtesy of the Othello Community Museum.)

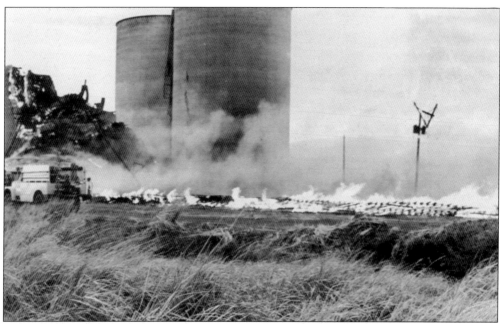

Lauer was one of the many small stations on the Milwaukee Branch to Marcellus. The branch was built to tap the rich dryland wheat area north of the main line that may have been shipping wheat to the reasonably close Great Northern main line farther north. Most of the grain elevators on the line are still open and operated by Odessa Union Warehouse, including Lauer. In the 1970s, the grain business was good. In 1984, after the railroad was abandoned, the old wooden buildings caught fire and quickly burned. (Courtesy of the Odessa Historisches Museum.)

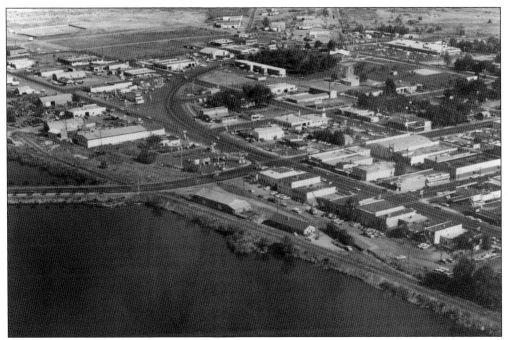

This 1966 aerial view of Moses Lake was shot by Milwaukee Road photographer Robert McCoy. The freight house is closest to the road that goes out into the lake, and the depot is just to the lower right of that. The depot and the freight house are long gone, as are all but the tracks closest to the lake. (Photograph by Robert McCoy, courtesy of Nate Molldrem.)

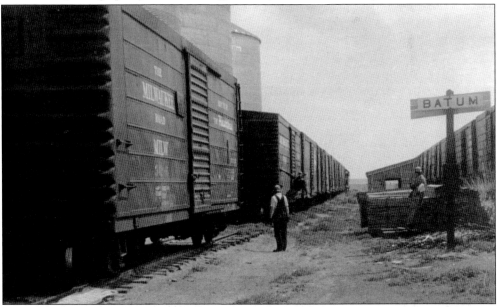

Because of the many Russians who moved into the area to grow wheat, Batum was named for a city in the Caucasus region on the east coast of the Black Sea in Russia. Here, the crew is switching cars at the not-often photographed location. The boxcars, with distinctive horizontal ribbing, were built by the Milwaukee in its own shops. (Photograph by J. Foust, courtesy of the Othello Community Museum.)

The train to Marcellus has stopped at Packard to perform some switching in May 1979. Packard had once been a small but bustling town, but two grain elevator fires, the first in 1921 and the second in 1946, really slowed down the vitality of the town. (Photograph by J. Foust, courtesy of the Othello Community Museum.)

This was the location of the switch to the track that went to the south of the depot, just behind the photographer. Both of these tracks are gone today. The white powder in this 1980 photograph is ash from Mount St. Helens. The area today has a nice lawn and concrete trail. (Photograph by Dorothy Kimball, courtesy of Mike and Penny Kimball.)

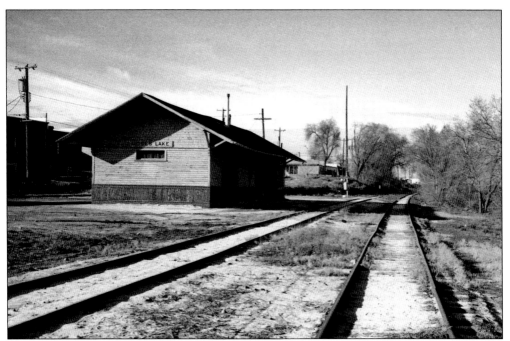

The Moses Lake depot location is now a park, with a paved trail along where the track to the left of the depot used to be. The tracks on the far right are still in place. The depot was torn down not long after this 1981 photograph was taken. The long-gone freight house used to sit between the depot and the city street. (Photograph by S.L. Dixon.)

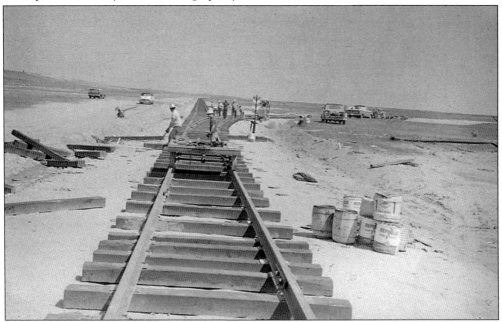

Construction is progressing nicely along the tracks just outside of Royal City. This view, looking east, shows the empty land that will soon sprout warehouses and the such. The track curving to the right is the connecting track to the main line a few miles away. (Courtesy Moses Lake Museum & Art Center.)

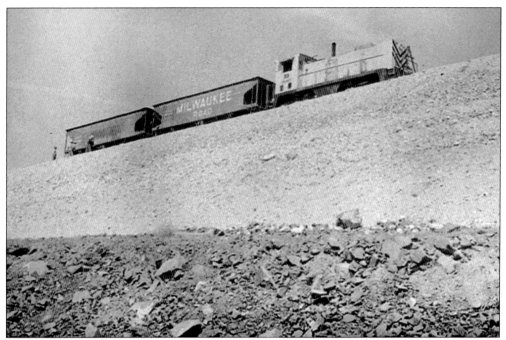

A contractor's locomotive helps construction workers place ballast along the tracks as part of the final steps of preparing the line to Royal City for operation in 1967. (Courtesy Moses Lake Museum & Art Center.)

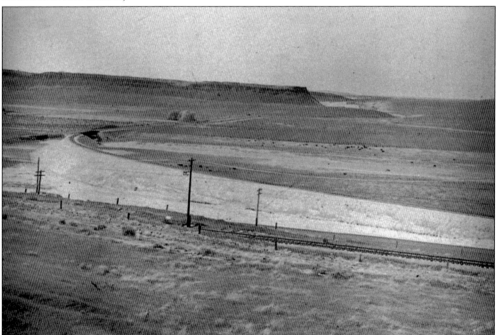

The first part of the branch curved hard from the main line, closest to the bottom of the photograph, and headed north and down toward the bottomlands along Crab Creek. Royal City is up on the far bench of land, so the tracks had to climb a steady 2.2-percent grade at one point, with a horseshoe curve as well. (Courtesy Moses Lake Museum & Art Center.)

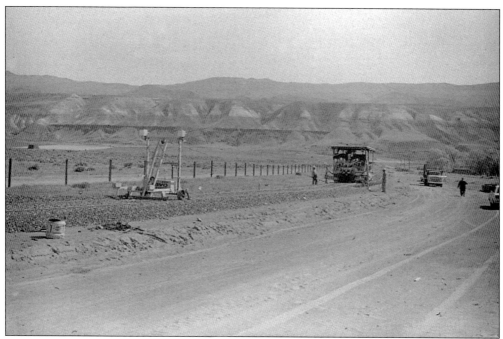

The firm of Dravo-Degerstrom of Spokane was the contractor in charge of building the six-mile branch to Royal City. The work was carried out under the supervision of the railroad's division engineer, T.M. Pajari. Here is a mechanical tamper, which was used to help settle the ballast between the ties. This is located along the gentle climb out of the Crab Creek area but before the heavy grades and horseshoe curve across Red Rock Coulee. Most of the grading for the track was completed in 1966, and the whole project was to cost around $1 million. (Both courtesy of the Moses Lake Museum & Art Center.)

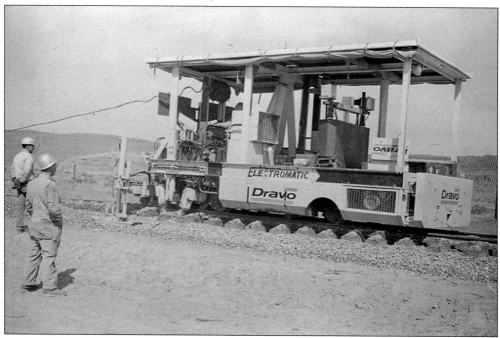

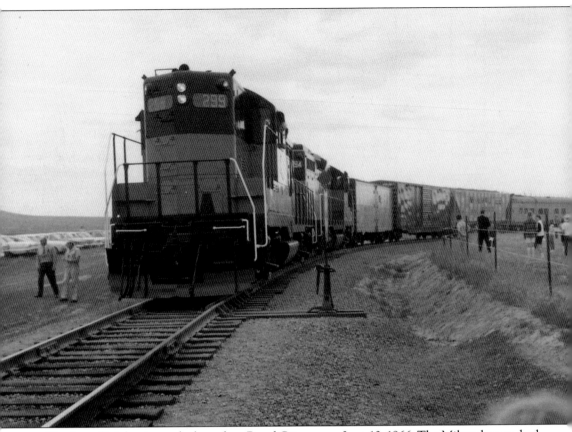

The first official train on the branch to Royal City was on June 10, 1966. The Milwaukee washed and waxed two locomotives and cleaned up a few of its newest cars, which represented the type of cars to be used on the new branch, and had a grand-opening ceremony. It had been decades since any new branch lines had been built on "Lines West," so it was quite an occasion. The Milwaukee Road traffic department probably milked it for all the public relations it could get. The next day, the department probably started switching the line and bringing out its usual beat-up cars for loading products at the various industries. (Courtesy of the Grant PUD Photograph Archives.)

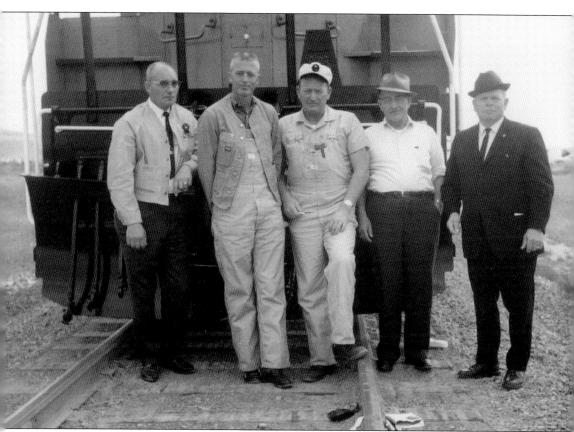

This is the crew of the first official train to operate on the Royal City Spur. From left to right are unidentified, Dick Donley, Dick Nelson, Ernie Knott, and Bob Camp, dressed for his job of union representative. Camp's presence was to be the arbitrator between enforcing the union rules and the company, who tried to disallow extra time that trainmen claimed for unusual things that happened during a trip, such as being the first train on the line. (Photograph by Wade Stevenson, courtesy of the Othello Community Museum.)

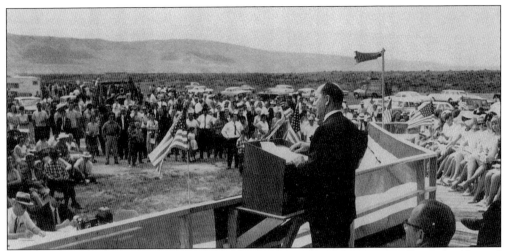

On opening day of the Royal City Branch, Milwaukee Road president Curtiss Crippen addressed the crowd. He is thought to be the last president of the railroad who truly wanted the Milwaukee to be successful. (Courtesy of the Othello Community Museum.)

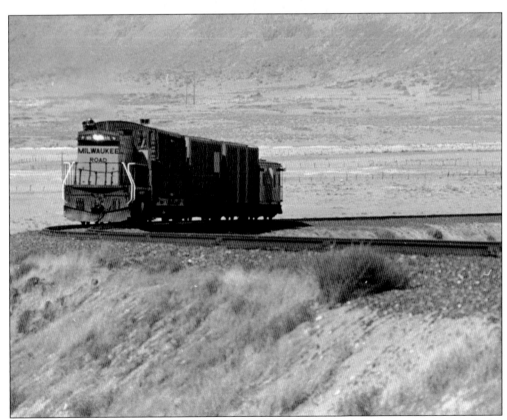

A typical mid-1970s local train from Royal City is seen rounding the curve to meet up with the main line at Royal City Junction. After entering the main line, the train will make the short trip back to Othello, where the cars will quickly be inserted into a through freight. (Photograph by Wade Stevenson, courtesy of the Othello Community Museum.)

Four

THE US CONSTRUCTION RAILROAD

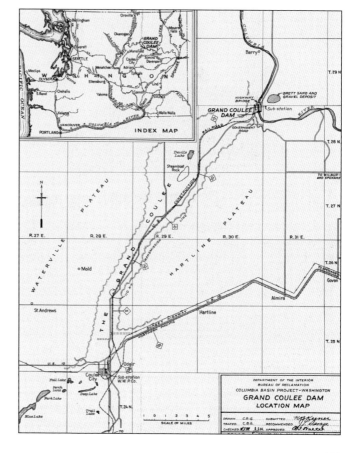

This map, drawn by the US Bureau of Reclamation, was part of a set of specifications produced and handed out to prospective bidders of the building of Grand Coulee Dam and all the support facilities. It provided those who were not familiar with the location of the dam the exact place it was to be built. The book provides exact measurements for every aspect of building the dam, including where the railroad was to be placed.

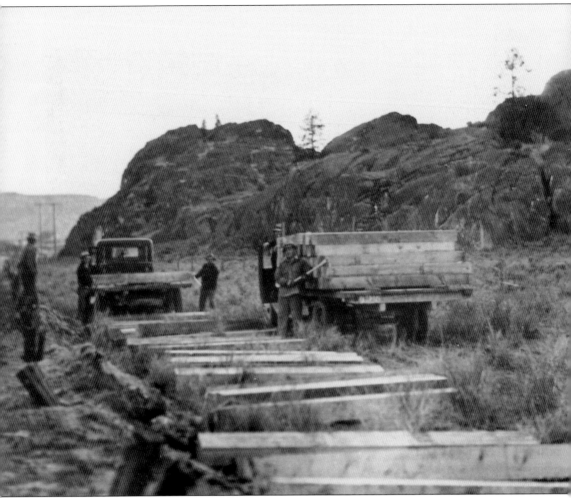

Since building the construction railroad between Coulee City and Grand Coulee happened during the Great Depression, labor was quite cheap and in abundance. Also, the line itself did not have a lot of heavy construction to complete the grade, so a few machines, some animals, and human labor were all that were needed to easily build the line. Note that the railroad ties are not treated with creosote, a normal railroad practice. Creosote would increase the cost of construction but prolong the life of the ties in the dry environment of the Grand Coulee area. The railroad was not expected to last much beyond the construction of the dam. (Photograph by the US Bureau of Reclamation.)

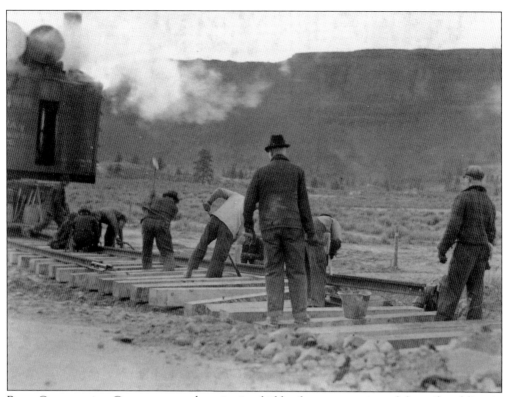

Ryan Construction Company was the winning bidder for construction of the railroad line in 1934. It had a small crew of men out in the coulee, laying rail with a crane. (Photograph by the US Bureau of Reclamation.)

While construction of the grade was done with a minimum of major equipment, the recently invented road grader was used. The road grader pictured is being steered by the guy on the back while being pulled by the tractor. This very grader was recently discovered sitting near a pile of scrap metal outside of the locomotive maintenance shed at Odair and was removed for preservation. (Photograph by the US Bureau of Reclamation.)

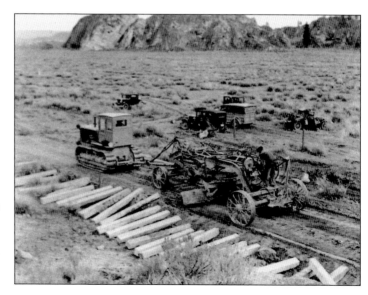

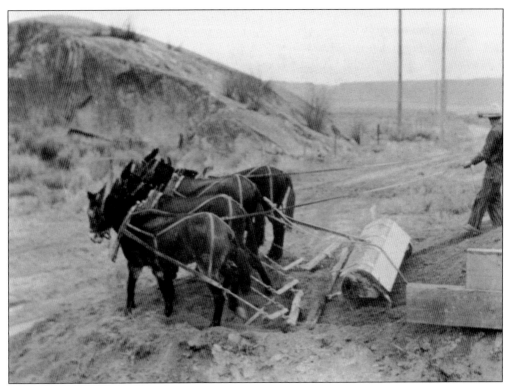

Part of the solution to keep costs low when building the railroad was the use of mules for heavy grade leveling. Understand that when contractor Ryan Construction Company submitted a bid, it had in mind to do the work to the minimum standard, at the lowest cost, with the most profit to the company. Mules would fit this profile just fine. (Photograph by the US Bureau of Reclamation.)

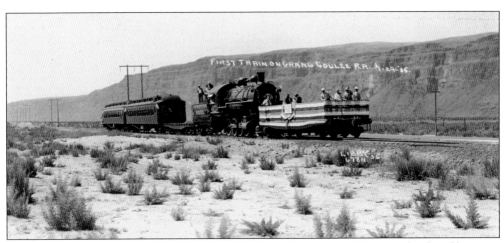

This may have been the only passenger train to traverse the newly constructed railroad between Coulee City and Grand Coulee Dam. With Gov. Clarence D. Martin at the throttle, the special train marked the grand opening of the new railroad line between those two cities. (Courtesy of John Phillips III.)

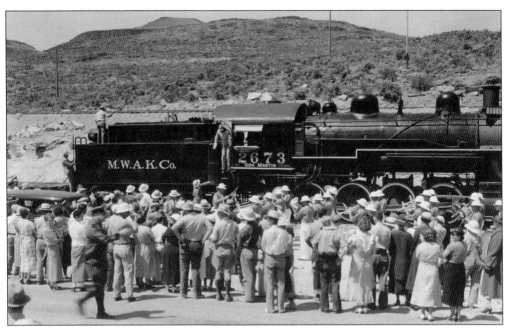

Gov. Clarence D. Martin is alighting from the cab in full engineer's garb. The locomotive itself was new to the line, having previously served on the Southern Pacific since being built in 1903. It must not have been in the best shape, as in two years it was set aside out of service. (Photograph by the US Bureau of Reclamation, courtesy of the Grant County Historical Museum.)

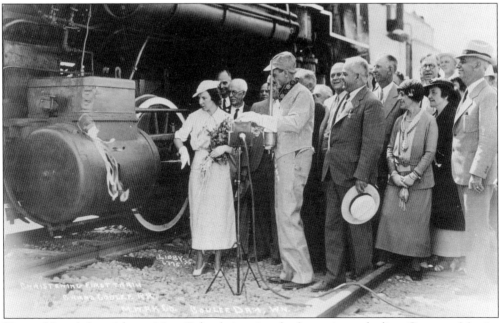

Pictured from left to right are Mary Cole, christening the first train on the line; Governor Martin, dressed as the engineer; Rufus Woods of the Wenatchee World; Rosalie Gardiner Jones, whose husband pushed for congressional approval; and behind her with the glasses is James O'Sullivan, a driving force to get the Dam built. As of publication, Ms. Cole still resides in the Big Bend. (Courtesy of Mike Denuty.)

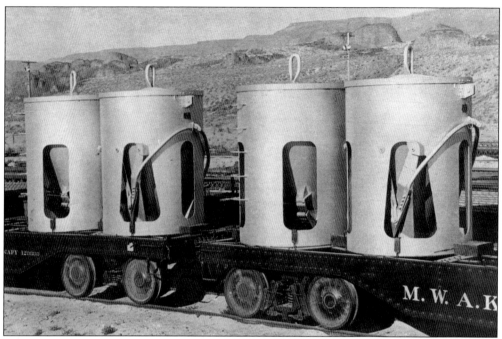

Freshly delivered cement buckets and flatcars are seen at the Electric City yard before being placed into service. The curved bar on the right-hand side of the two buckets opened the bottom of the buckets, allowing the cement to flow out. (Courtesy of the Hu Blonk Papers, EWU Archives, Image Number 5-19-4.)

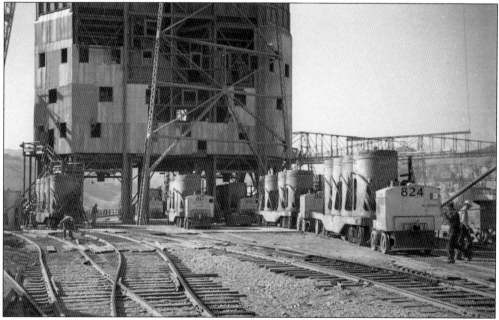

This is the scene below the mix plant, showing trains of cement buckets to be loaded. The diesel-electric locomotives were built by the Davenport Locomotive Works and weighed 10 tons. One of these survives today, in a modified form, at the Northern Pacific Railway Museum in Toppenish. (Courtesy of the Hu Blonk Papers, EWU Archives, Image Number 5-35-12-B1.)

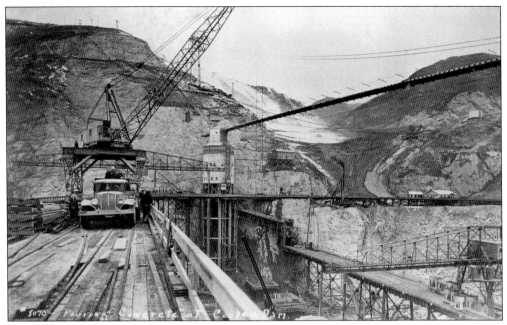

The trestle that the photographer is standing on was connected to the main railroad tracks in the area. One can follow the trestle toward the back of the scene, around to the right where it connected to a small yard, and then to the switchbacks that helped the line climb the hill. (Courtesy of the Hu Blonk Papers, EWU Archives, Image Number 5-22-2.)

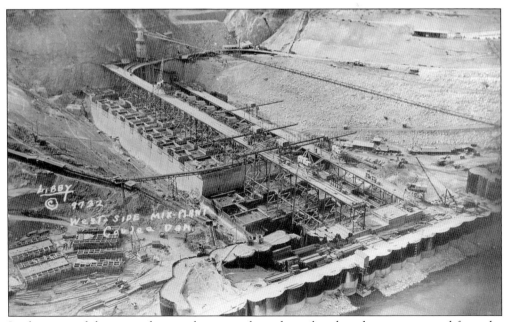

In this view of the west-side mix plant, note how the railroad grade sweeps around from the hillside in the background and connects with the construction trestle across the work site. Note the flatcars laden with cement hoppers, pulled by small locomotives near the Whirley cranes on top of the trestles. (Courtesy of John Phillips III.)

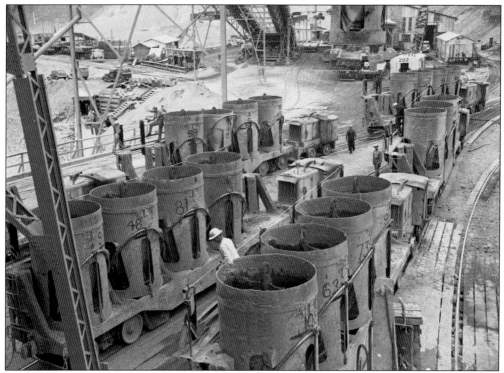

Here is another scene showing the spaghetti bowl of tracks near the mix plant, along with the many cement buckets and locomotives. Part of the extensive conveyor works that moved rock around the area can also be seen. (Courtesy of the Hu Blonk Papers, EWU Archives, Image Number 5-33-12-B1.)

There were large silos at the dam site to hold bulk cement that the railroad had delivered. Note the building on the left with the boxcar tucked in below the awning. It is likely being unloaded, and the cement is being handled via the auger to the silo. (Courtesy of the Hu Blonk Papers, EWU Archives, Image Number 5-18-8.)

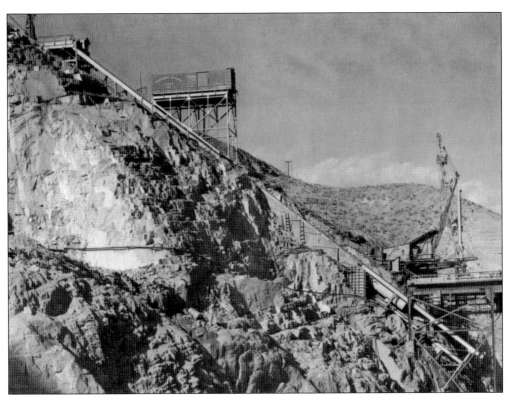

This unique photograph shows the car skip in operation during construction of Grand Coulee Dam in 1935. Built on the left abutment of the dam, this incline lowered or raised cars between the construction railroad and the trestle deck. It allowed loads to be quickly moved. Cement was loaded into these boxcars in bulk. (Photograph by the US Bureau of Reclamation.)

Compare this view with the previous image of the John W. Keys III Pump-Generating Power Plant. Now, the car skip is obscured, though the tracks leading to the base of the dam are still in place. This spot is somewhat recognizable today, but the highway through here has been widened enough to obliterate the railroad grade. (Courtesy of the Hu Blonk Papers, EWU Archives, Image Number 5-14-28.)

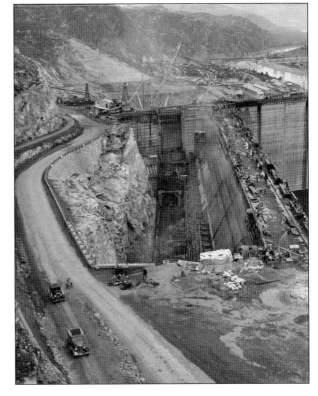

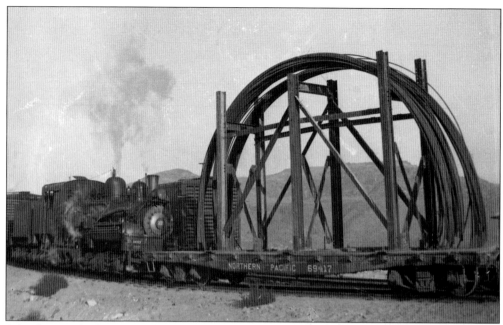

A load is switched out at the yard above the dam site, located right before the heavy grade down to the construction level. Locomotive No. 200 was built in 1926 and purchased by Mason-Walsh-Atkinson-Kier in January 1936. It was the first of the Shay-brand logging-style locomotives to operate at the dam site. (Courtesy of the Hu Blonk Papers, EWU Archives, Image Number 5-36-12-B1.)

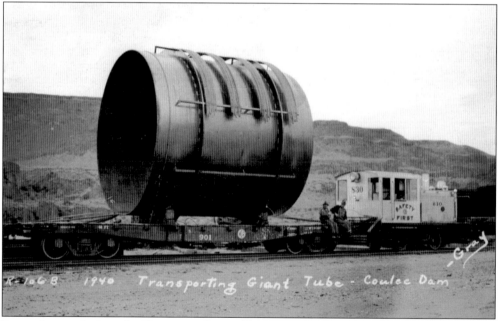

Penstocks were built at the fabrication plant in Electric City and were far too large to ship by rail. Here is one of the 18-foot sections ready to depart for the dam. Locomotive No. 830 was built new for Consolidated Builders, Inc., in February 1939. This view shows the north wall of the Grand Coulee in the background. (Courtesy of John Phillips III.)

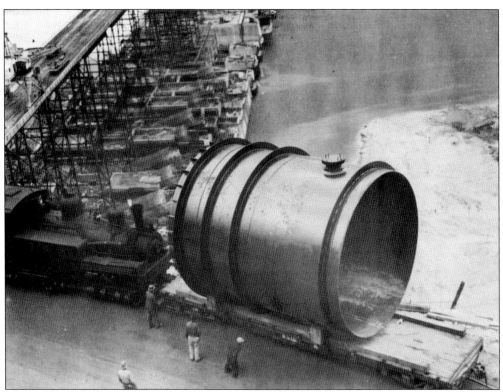

This penstock section is being lowered downgrade from the fabrication plant at Electric City. Note this type of locomotive, a Shay, which featured reduction gearing, is particularly suited to steep grades, slow operations, and heavy loads. The round object on the top of the penstock segment is a manhole cover. These access points are still used inside the galleries of the dam. (Photograph by the US Bureau of Reclamation.)

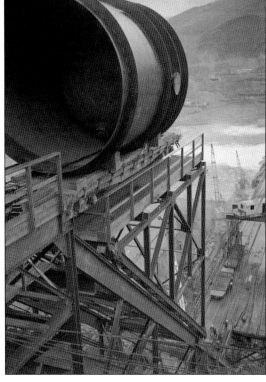

The car skip was used to move large parts down to the level they were needed. Here is a piece of penstock, loaded on a flatcar, to be dropped down to the construction trestle for further movement. (Courtesy of the Hu Blonk Papers, EWU Archives, Image Number 5-36-11-A3.)

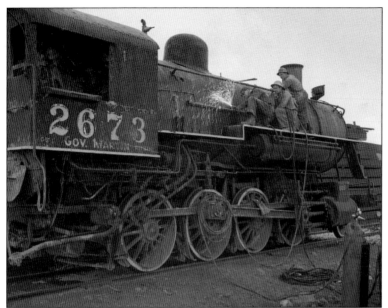

No. 2673 only served two years on the line to Grand Coulee before it was considered junk and cut up for scrap. While these men could easily be repairing the locomotive, note that the cowcatcher is missing from the front. (Courtesy of the Hu Blonk Papers, EWU Archives, Image Number 5-39-11-A4.)

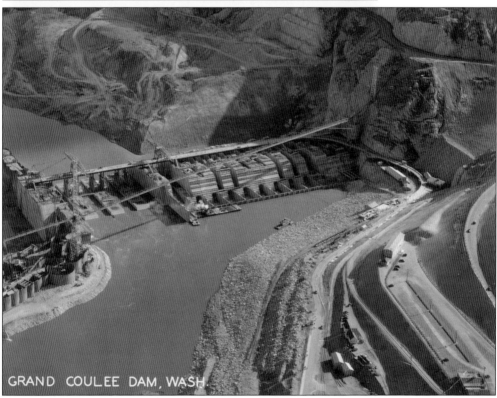

GRAND COULEE DAM, WASH.

The depth of the dam below the coulee made it difficult for a traditional railroad to be built. Five-percent grades were accepted for the project, including a number of switchbacks, due to the limited room in the construction zone. Note here the few different switchbacks the railroad used. The highway, still in use today, curves through the image at the right. (Photograph by the US Bureau of Reclamation.)

The two most important visitors on the train crossing Grand Coulee Dam on October 25, 1938, other than construction supervisor Frank Banks were Secretary of the Interior Harold L. Ickes and the Commissioner of Reclamation John Page. At right, Ickes is seen below the locomotive number, and Banks is to the left of him. Ickes's trip to Grand Coulee was part of a much larger one that he took with his wife, Jane, starting on October 16, 1938. This trip was, in part, a chance for Ickes, along with Page, who was responsible for getting the projects implemented, to inspect a number of US Bureau of Reclamation projects that were under way throughout the West. (At right, photograph by the US Bureau of Reclamation, courtesy of the Grant County Historical Museum; below, courtesy of the Hu Blonk Papers, EWU Archives, Image Number 5-36-1-B1.)

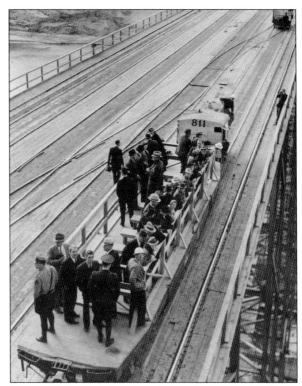

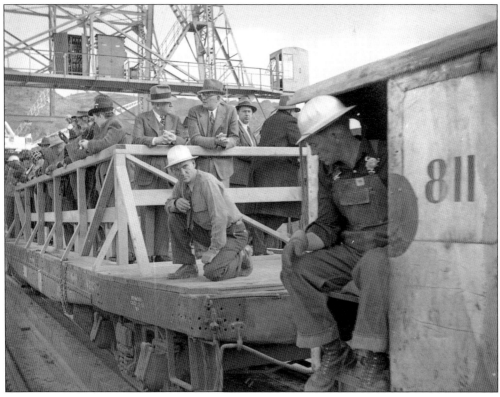

A yard at Electric City was built to sort construction materials and to assemble certain parts before shipping to the actual site. This area, seen on December 15, 1937, is now completely under water. The photographer is standing in between today's Coulee Playland and North Dam Park, and he is looking northwest. (Photograph by the US Bureau of Reclamation, courtesy of the Grant County Historical Museum.)

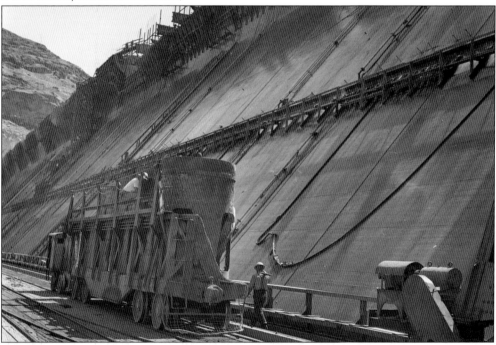

There were many flatcars in use that carried the concrete buckets from the mix plant to the pour site. Of note is this one, equipped with some fencing, not unlike a cowcatcher on a steam locomotive, to help keep things from getting underneath the car. (Courtesy of the Hu Blonk Papers, EWU Archives, Image Number 5-33-12-A3.)

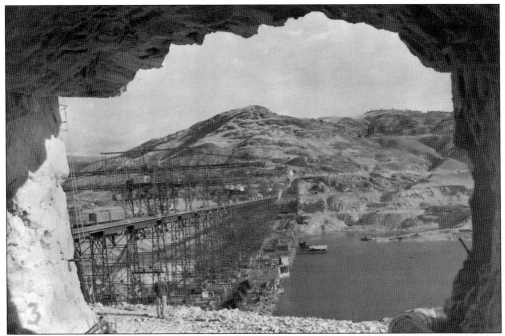

This 1939 view is courtesy of one of the holes drilled into the west hillside for the discharge pipes used to carry water to what would become Banks Lake. This photograph shows the upstream side of the dam. Note the Northern Pacific boxcars traveling across what would become the face of the dam. (Photograph by the US Bureau of Reclamation, courtesy of John Phillips III.)

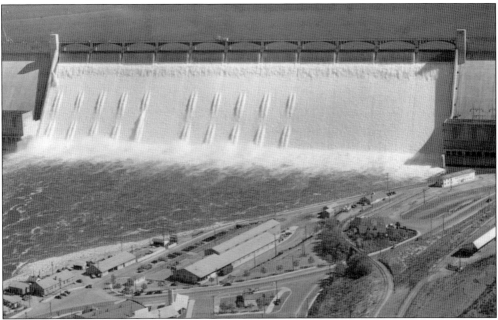

Most everything but the dam has changed in this May 1944 view. Note the Green Hut restaurant, just above the crossing of the railroad tracks and the highway; it is now the site of the visitor's center. Also note the railroad tracks bordering the water just opposite of the spillway. They were removed after the floods of May 1948, ending a popular tourist train ride.

This boxcar got loose at the small yard just above the dam site and nearly rolled onto the road and tracks below. Most of the boxcars used to bring cement to the dam were stenciled "Coulee Dam Cement Service" to keep them from being assigned to other duties that would require a thorough cleaning of the car first. (Courtesy of the Hu Blonk Papers, EWU Archives, Image Number 5-39-14-B3.)

The railroad brought in many premade parts to the dam site. This load of ring seal gates for the 102-inch diameter outlet works, located on top of the construction trestle along the face of the dam, will be lifted off the flatcar by the crane in the background. (Courtesy of the Grant Historical Society Museum.)

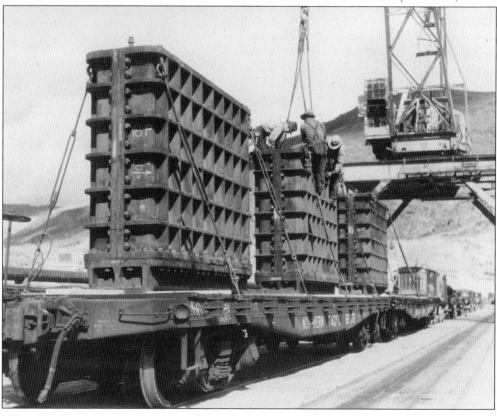

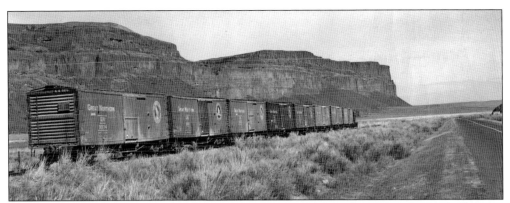

Most trains bound for Grand Coulee were just like this one on April 6, 1949: composed of boxcars of bulk cement. There were different sources of cement for use in construction to help meet the incredible demand. These particular cars more than likely were handed off by the Great Northern to the Northern Pacific at Adrian, Washington, for delivery to the construction railroad at Odair. (Courtesy of the Grant County Historical Museum.)

Conductor Floyd Craig (left) had been with the road since the first spike was driven in 1934. Engineer Haskell Finch (right) joined up about the time the hauling started. Fred A. Warren (center) had been superintendent all but two years since the government took charge of running the road from Consolidated Builders, Inc., after the dam was completed. The bureau would continue to operate the switchyards at Odair after the track removal. The "IDBR" on the locomotives stands for "Interior Department Bureau of Reclamation." (Photograph by the US Bureau of Reclamation, courtesy of the Grant County Historical Museum.)

In late 2011, the US Bureau of Reclamation lowered Banks Lake. This time of low water allowed many sections of the old grade to be visible for the first time in years. Looking approximately north with Steamboat Rock to the immediate left is a grade crossing with two remaining railroad ties. This photograph was taken 60 years after the rails were pulled up.

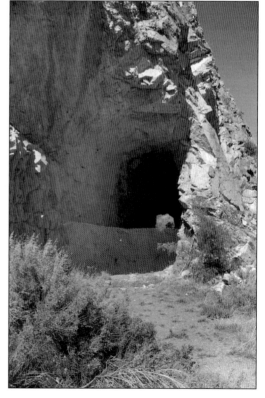

A tunnel was built behind what is now city hall of Coulee Dam. It was blasted through granite and was on a steep five-percent grade. Though the logging locomotives used here would have no problems with it, the tunnel was not used due to a poorly constructed bridge downgrade from here. Because the rock inside the tunnel is not stable, access has been blocked.

Five

THE MON-ROAD RAILROAD

Monte Holm operated a successful junkyard for many years, which fit in with his longtime job of scrapping logging railroads and such throughout the Pacific Northwest. He unsuccessfully tried to get the Milwaukee Road to build a spur into his junkyard if he would ship 50 cars by the second year of operation. (Courtesy of Steve Rimple.)

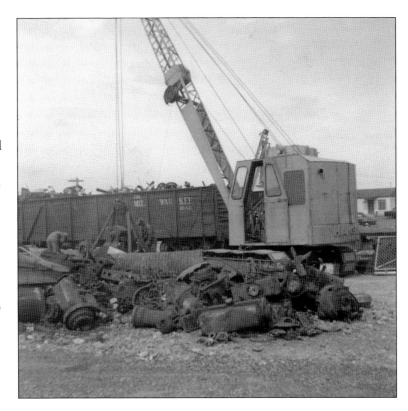

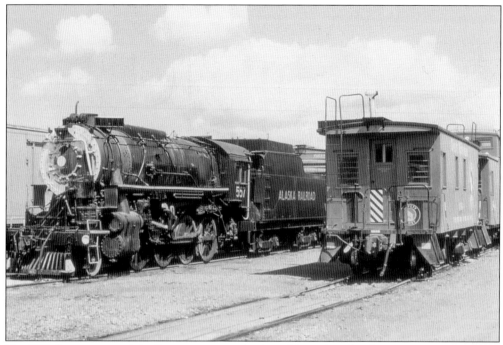

No. 557's first stop out of the Everett scrap yard, where Monte bought the engine, was the Great Northern yard. It was there that the engine was interchanged to the Milwaukee Road for shipment to Moses Lake. (Photograph by George Simonson, courtesy of Allen Miller.)

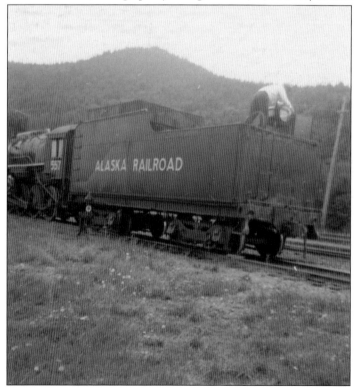

After the Milwaukee Road hauled No. 557 to Cedar Falls, arrangements were made to keep the headlight on the tender to keep it from wandering off in transit. Here, Monte is working on said item. (Courtesy of Steve Rimple.)

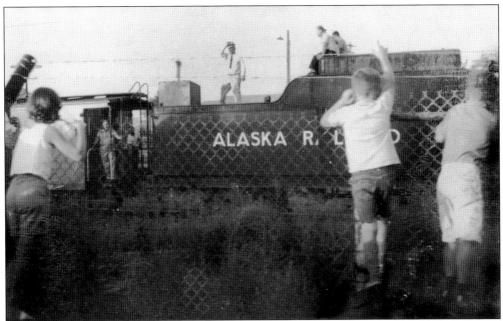

No. 557 arrived in Moses Lake in 1965 after being sold to an Everett, Washington, area junkyard. Monte and two of his friends rode the engine from Warden to Moses Lake. (Courtesy of Steve Rimple.)

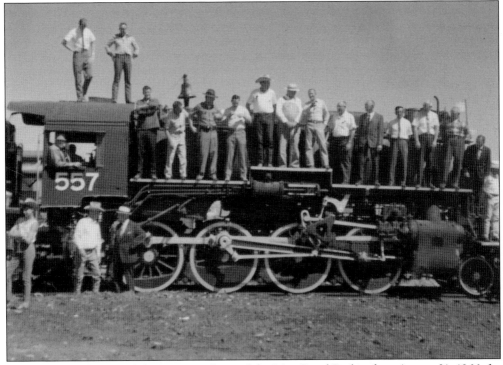

Monte gathered many of the vice presidents of the Mon-Road Railroad on August 21, 1966, for this portrait. Letterhead was drawn up for "official" use naming all of these vice presidents, who were actually close friends. (Courtesy of Steve Rimple.)

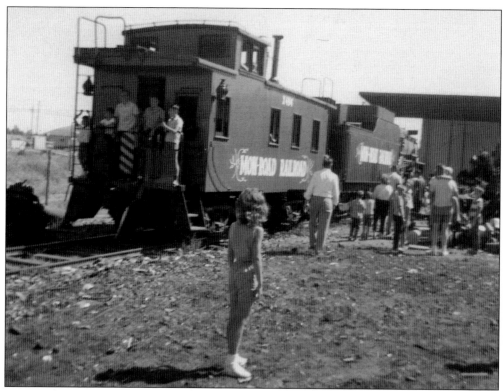

On November 19, 1964, it was announced that Larson Air Force Base would close in June 1966. The announcement caused a frenzy in the Moses Lake area, as citizen groups mobilized to identify public or private usages for the Larson site. Their efforts eventually paid off in the opening of the Grant County Airport on October 8, 1966. Part of the festivities was Monte's train being steamed up to visit the airport. Here it is, ready to be used. The name on the caboose and steamer were chosen as part of a name-the-train contest in 1965. (Both courtesy of Steve Rimple.)

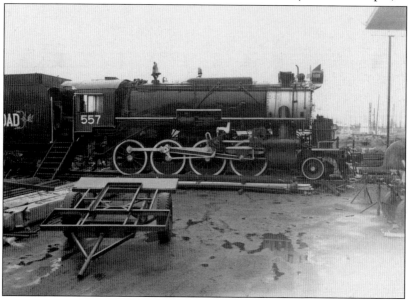

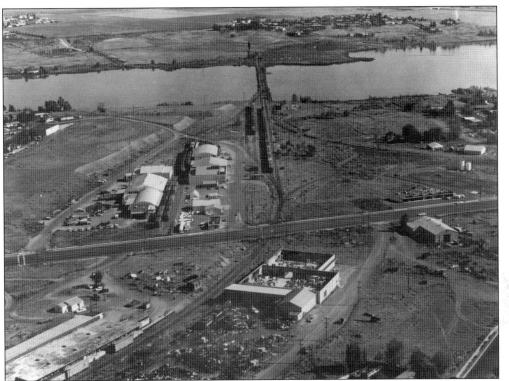

Here is another photograph by Robert McCoy for the Milwaukee Road. This time, it shows part of the industrial area just to the south of the downtown area of Moses Lake. Sharp-eyed readers will see the then recently acquired Alaska Railroad steam locomotive inside Monte's junkyard. (Photograph by Robert McCoy, courtesy of Nate Molldrem.)

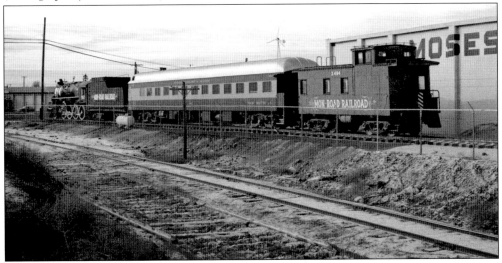

This is how Monte's train looked for years sitting along Broadway in Moses Lake. The caboose, of Great Northern heritage, still sports its original number. The business car, sold off by the Burlington Northern in the early 1970s, is still in its original paint but with a new name. The spur to a potato warehouse had recently been removed in this April 1981 photograph. (Photograph by S.L. Dixon.)

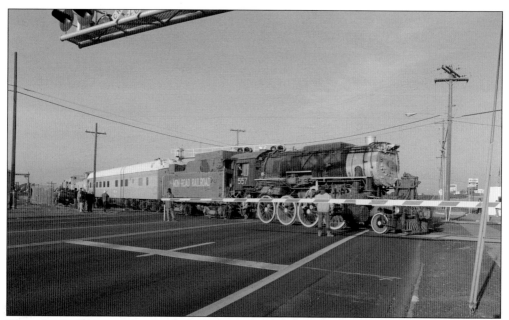

December 8, 2011, was a big day in the history of Moses Lake as No. 557 rolled out of town having been sold after Monte passed away. Most townspeople, including those at the local newspaper, were unaware that the move was happening that day. This was used as the lead photograph in the next day's paper.

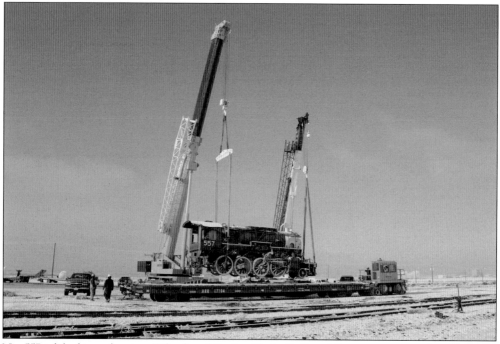

No. 557 is lifted into the air at Wheeler while the Alaska Railroad flatcar is positioned underneath. A crew from the Alaska Railroad and a contractor had come to affix the engine to the flatcar, which was then shipped to Seattle and barged to Alaska. No. 557 is currently being restored for service.

Six

THE WATERVILLE RAILROAD

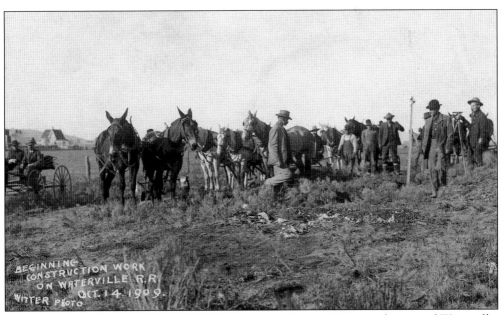

Construction work on the Waterville Railway started in 1909 just to the east of Waterville. Residents wanted rail service to their town and organized their own railroad after realizing that the Great Northern would get no closer than Douglas, about five miles away. (Courtesy of Darrin Nelson.)

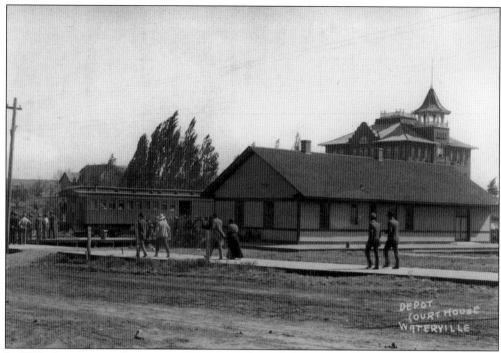

In 1911, the train was the easiest way to get to the courthouse in Waterville. This image depicts how close the depot is to the courthouse. Judging by the number of people walking to the train, it must nearly be time for it to depart backwards to the wye, where it will turn and face forward for the trip to Douglas. (Courtesy of Darrin Nelson.)

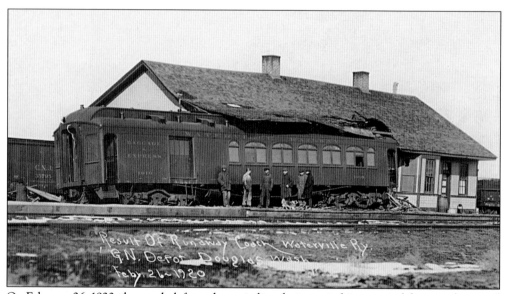

On February 26, 1920, the coach, left on the main line during switching, started downgrade toward Douglas. The grade was steep, and the coach sped away. At Douglas, it went around the wye with the Great Northern, ran up the grade for nearly half a mile, and careened off the track just as the Douglas depot was reached. No one was seriously hurt. (Courtesy of Darrin Nelson.)

The depot that the Waterville Railway used was a standard-plan Great Northern depot. This was due to the close relationship between the two lines during construction of the five-mile line between Douglas and Waterville. The Great Northern even loaned the rails that were used. The depot was sold after the railroad left and is still in use as a private residence.

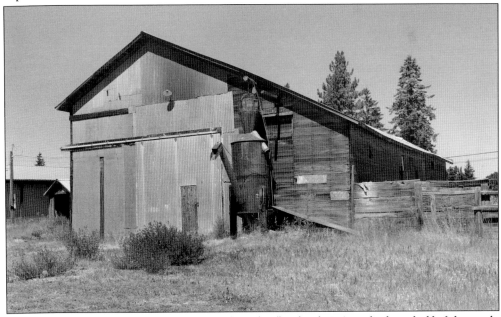

Long after the railroad ceased to operate when the floods of 1948 washed out half of the track, the engine house in Waterville still stands. The building was sold off in 1975 after the railroad corporation was dissolved. Inside, there was once a hand-operated hoist used for loading coal into the tenders of the steam locomotives.

DISCOVER THOUSANDS OF LOCAL HISTORY BOOKS FEATURING MILLIONS OF VINTAGE IMAGES

Arcadia Publishing, the leading local history publisher in the United States, is committed to making history accessible and meaningful through publishing books that celebrate and preserve the heritage of America's people and places.

Find more books like this at
www.arcadiapublishing.com

Search for your hometown history, your old stomping grounds, and even your favorite sports team.